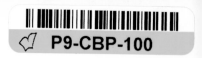

Through
Romantic Eyes

Portrait of
Demetrios M. Botsaris
(cat. no. 64)

THROUGH ROMANTIC EYES

European Images of Nineteenth-Century Greece
From the Benaki Museum, Athens

Fani-Maria Tsigakou

ART SERVICES INTERNATIONAL
ALEXANDRIA, VIRGINIA 1991

Meridian House International
Washington, D.C.

Frick Art Museum
Pittsburgh, Pennsylvania

Society of the Four Arts
Palm Beach, Florida

Knoxville Museum of Art
Knoxville, Tennessee

Dixon Gallery and Gardens
Memphis, Tennessee

The exhibition is organized and
circulated by Art Services International,
Alexandria, Virginia.

Support for the exhibition has been
provided by the Greek Ministry of Culture,
the Greek National Tourism Organization,
and the Greek Friends of the Benaki Museum.

Library of Congress
Cataloging-in-Publication Data
Tsigakou, Fani-Maria
Through romantic eyes : European
images of nineteenth-century Greece, from the
Benaki Museum,
Athens / Fani-Maria Tsigakou.
 p. cm.
 Includes bibliographical references.
 ISBN 0-88397-099-6
1. Greece in art—Exhibitions. 2. Art,
European—Exhibitions. 3. Art, Modern—19th
century—Europe—Exhibitions. 4. Romanticism
in art—Europe—Exhibitions. 5. Mouseion
Benakē—Exhibitions.
I. Mouseion Benakē. II. Title.
N8214.5.G8T784 1991
758'.9949506—dc20 91-13948
 CIP

Editor: Nancy Eickel
Designer: Grafik Communications, Ltd.
Photographer: Andreas Skiadaressis

Printed in Hong Kong by
South China Printing Co.

Cover: Detail of *View of the Acropolis
from the Pnyx* (cat. no. 3)

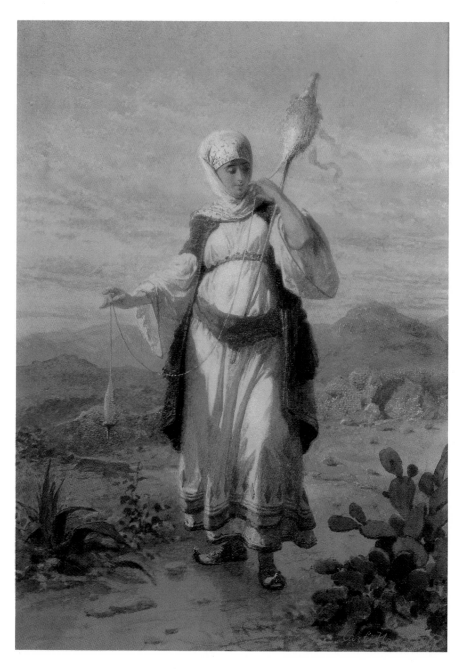

A Greek Girl Spinning (cat. no. 29)

Contents

Acknowledgments

Fascination with travel and exotic places has long lured people to distant lands. To increase the appreciation of art from other countries and to further scholarship, Art Services International has developed a wide-ranging program of exhibitions from international collections. Master works from Berlin, London, Rotterdam, and Lisbon have composed some of ASI's recent exhibitions, and now it is with great pride that we present these exceptional paintings, watercolors, and drawings from the Benaki Museum in Athens.

Ancient Greece, the cradel of Western civilization, proved enticing to scores of Europeans in the nineteenth century. Artist-travelers armed with sketchpads and paint brushes made pilgrimages to the sites recalled in classical literature and mythology. Steeped in the Romantic aesthetic then so popular in Europe, painters often recorded modern Greece more as they wished it appeared rather than as it actually did. These works, rendered in the Romantic spirit, evoke a desire to return to the seemingly simpler age of classical antiquity.

Guiding us on this journey of Greece as viewed by European artists in the nineteenth century is Dr. Fani-Maria Tsigakou, Curator of Paintings, Prints and Drawings at the Benaki Museum. Her years of research on the subject, including her extensive writings on Edward Lear's travels in Greece, are evident in her engaging catalogue text. We cannot thank her enough for sharing her expertise with us. Her patience and dedication throughout the organization of this project were of heroic proportions, and she is greatly admired.

Dr. Angelos Delivorrias, Director of the Benaki Museum, has been especially generous in lending such a key selection of paintings and works on paper for this American tour, and also in serving as a link with the Greek government. Such trust and cooperation on an international level merits special mention, and we send him our personal thanks.

We are honored to have this opportunity to credit the Greek Ministry of Culture, the Greek National Tourism Organization, and the Greek Friends of the Benaki Museum for their valuable support of this project. Our gratitude also extends to Ambassador Christos Zacharakis, who has graciously agreed to serve as Honorary Patron of this exhibition throughout its tour.

Joining us in our eagerness to acquaint American audiences with these Romantic interpretations of Greece are the directors and curators of the institutions participating in the exhibition's tour: Ambassador Walter L. Cutler and Nancy Matthews, Meridian House International, Washington, D.C.; DeCourcy E. McIntosh and Alan Fausel, Frick Art Museum, Pittsburgh; Robert W. Safrin and Nancy Mato, Society of the Four Arts, Palm Beach; Kevin Grogan and Stephen Wicks, Knoxville Museum of Art, Knoxville; and John E. Buchanan, Jr., and Sheila Tabakoff, Dixon Gallery and Gardens, Memphis. We are appreciative of their interest and support.

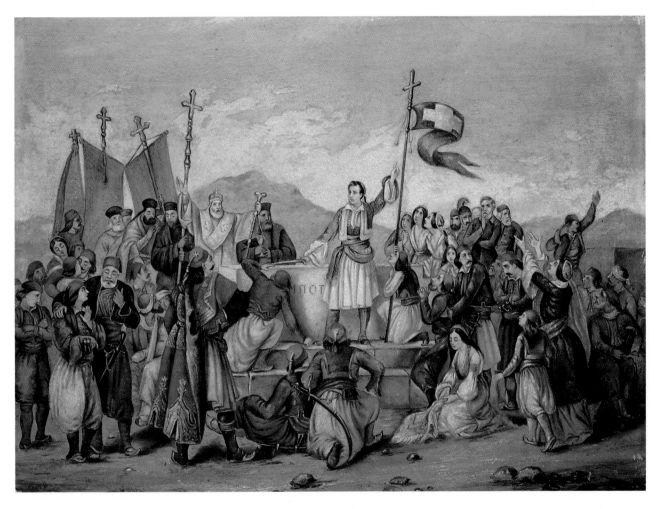

Ably preparing and overseeing the production of the exhibition's catalogue was our editor, Nancy Eickel. Her efforts, combined with the photography skills of Andreas Skiadaressis in Athens and the design talents of Grafik Communications, Ltd., resulted in this handsome catalogue, and we acknowledge their professionalism.

The contribution of Mrs. John A. Pope, Trustee of Art Services International and consultant on this project, once again warrants our sincere appreciation. Her unending enthusiasm and concern for ASI exhibitions are warmly received.

Most deserving of our praise is the staff of Art Services International. Marcene Edmiston, Donna Elliott, Margaret Frazier, and Sally Thomas once again enlisted their skills and perseverance to the successful realization of this exciting exhibition.

Lord Byron's Oath on the Tomb of Marcos Botsaris (cat. no. 57)

Lynn Kahler Berg
Director

Joseph W. Saunders
Chief Executive Officer

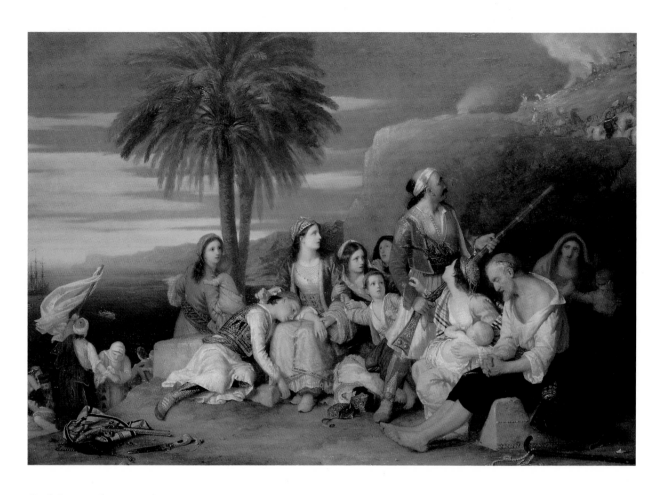

Greek Fugitives (cat. no. 67)

Preface

Even for those who possess little knowledge of mankind's cultural past, Greece undoubtedly represents something more than a geographic location. There is also no doubt that the idea of Greece arouses a chain of intellectual and emotional associations relating to the archetypal forms of Western concepts and values. The Greek ideal of beauty proved definitive for the aesthetic culture of the civilized world, not only in antiquity and the period of Roman domination, but also during the Renaissance and the Enlightenment.

When, from the late eighteenth century onwards, Europeans began to seek within Turkish-occupied Greece the reflections of its perished classical vitality, they discovered, to their astonishment, another hitherto unknown dimension of this ideal: the appealing nature of the cities and countryside, the limpidity of the Greek atmosphere, the spirituality of the Greek landscape and the clarity of its lines. They came to recognize the proud beauty of the Greek people and their moral values forged by their heroic struggle for independence.

The compulsive, effusive emotionalism that permeated the Romantic movement in the nineteenth century is evident beyond these European artists' images of Greece. Equally important was the influence exerted by the Greek model on Byron and Goethe, Pushkin and Hugo, Beethoven and Rossini. Since our exhibition deals with the visual aspect of this subject, the rest will be left to the viewer's curiosity and motivation, for in the words of an eminent contemporary Greek poet, "They must do something too."

What we had to do, we did in the best way possible, both at the level of selecting the works and writing the texts, and at that of organizing the exhibition's overall infrastructure. The invaluable contribution of Fani-Maria Tsigakou is admirably reflected in the high quality of the catalogue's text. Our active and pleasurable cooperation with Art Services International, and especially with its director, Lynn Kahler Berg, and chief executive officer, Joseph Saunders, was rewarding. Thus, we are pleased that our joint efforts to share with distinguished American museums and the American public our deep commitment to enhance the appreciation of human culture were able to bear fruit.

Dr. Angelos Delivorrias
Director, Benaki Museum

A Romantic Vision of Greece

To most people the word Greece arouses not only images of its natural beauty but also thoughts of the great ideas on which Western civilization is largely based. From time to time the light of ancient Greece led to short-lived "rebirths" or "rediscoveries" of the classical spirit and revealed a romantic desire for a renaissance of Greek antiquity. For many centuries Greece was, to Europeans, not a real country but a vision stemming from the spirit of the age, intertwined with contemporary historical, social, and religious aspects. This vision manifested itself in different ways at different times.

Before the sixteenth century Greece possessed an identity entirely based upon its past. Untraversed by the major trade routes between West and East, the country remained isolated and unknown except for its coast and the islands of the archipelago, which were visited by European merchants and pilgrims to the Holy Land. A purely intellectual curiosity in Greece took the form of admiration for ancient Greek literature and learning that overwhelmed the European Renaissance humanists—and which was fostered by the Byzantine émigré scholars who fled to the West after the fall of Constantinople to the Turks in 1453. Yet Europeans showed little interest in the country itself or its inhabitants, who from the middle of the fifteenth century were dominated by infidels.

What increasingly focused attention on Greece for its own sake was its antiquities and the hope of finding them. Like a magnet, this idea attracted greater numbers of connoisseurs, aristocratic travelers, and diplomatic emissaries, the latter sent by English and French courts to remove "ancient Greek marbles" for the embellishment of royal residences in those countries. Such expeditions always included an artist, whose task was to make on-the-spot sketches of the antiquities and their sites. In the following centuries it became an institution for wealthy travelers to bring along their own artist, who acted like today's photographer, recording events and locations for future reference (see cat. nos. 5, 10, 25, 37).

Growing interest in Greek antiquity was not, however, divorced from the political situation in the Levant. The Veneto-Turkish War in the mid-seventeenth century drew European attention to political and military developments in the area. This fostered a market for illustrated, serial publications that depicted the main battlefields, which were carefully drawn by skillful Venetian military draftsmen.

Before the eighteenth century, artistic theories deriving from Greco-Roman antiquity profoundly influenced European artistic practice, and classical history and mythology provided artists with a wide repertoire of themes and poses. Practically nothing from the actual heritage of Greek art or architec-

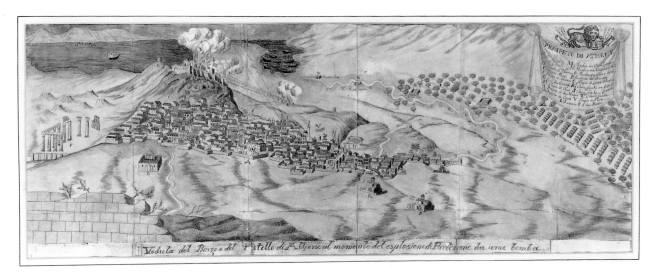

ture had been brought to light. Direct experience with Greek art became possible about the mid-1700s, largely through the discovery of the Greek temples at Paestum (1730) and the archeological excavations at Herculaneum (1738) and Pompeii (1748). The European aesthetic, which had been permanently held in thrall by Greco-Roman tradition, was now challenged by the monumental severity of the architectural vocabulary of Doric temples. In the frescoes of the excavated edifices European connoisseurs recognized the echoes of the perished masterpieces of the most eminent ancient Greek painters.

Protagonists in this process of recognition and advancement of the Greek style were the English Society of the Dilettanti, a club of aristocratic connoisseurs whose aim was to promote the "Grecian taste," and the German classicist Johann Joachim Winckelmann. In 1751, the artist James Stuart and the architect Nicholas Revett were sent to Athens by the Society of the Dilettanti to survey and execute systematic drawings of the classical monuments. Their joint efforts resulted in a four volume, lavishly produced publication entitled *The Antiquities of Athens Measured and Delineated* (1762-1816), a landmark in the history of aesthetics. That magnificent publication, sponsored by the Society of the Dilettanti, preserved what remained of ancient Greek architecture in illustrations that were both accurate and beautiful.

The spirit of ancient Hellas was most vividly evoked by Winckelmann. "Good taste was born under the sky of Greece," he wrote in his *Gedanken über die Nachahmung der griechischen Werke in der Malerei und Bildhauerkunst* (Reflections on the Imitation of Greek Works in Paintings and Sculpture), published in 1755. In his *Geschichte*

The Bombardment of the Parthenon by the Venetian Army on 26 September 1687
Hand-colored engraving
28.0 x 70.0 cm
After an original drawing made on the spot by Giacomo Milheau Verneda, an artillery officer in the Venetian army
Inv. no. 23149

der Kunst des Alterthums (History of the Art of Antiquity), published in 1764, in which he laid the groundwork for modern art history, Winckelmann also proclaimed the "superior humanity of the Greeks" and presented to the European public a glowing picture of the conditions that had fostered creative activity in ancient Greece. His contention that the highest ideals of human life and culture had been embodied in classical Greece came to be widely accepted throughout Europe. The process of idealizing the classical golden age had begun.

One result of promoting these ideals was an increased demand for information about Greece. In response, many European authors started writing about the life and sensibility of the ancient Greeks. Abbé Barthélemy, in his *Voyage du Jeune Anacharsis en Grèce* (1788), tantalized the imagination of his readers with his story of Anacharsis, a young Scythian who tours Greece seeking happiness from an enlightened nation. The description of Anacharsis' voyage furnished an idyllic panorama of the ancient world. The book went through forty editions and was translated into all the major European languages. During the Age of Enlightenment, the "Grecian taste" was reflected in a whole range of artistic activities, from art, music, and literature, to furniture design and the decorative arts, and even costumes and coiffures. In many American states newly founded cities were named after Athens, Sparta, Corinth, and Ithaca.

Grecomania knew no bounds in the 1800s. "Greek" became synonymous with the stylistically fashionable. For neo-classical artists the superiority of Greek art was an unquestioned matter of course, and the linear style of ancient Greek vases was believed to be the purest and most natural pictorial form. Furthermore, archeological accuracy was considered *sine qua non* for any true depiction of Greek themes, while a visit to Greece and the careful study of its surviving monuments came to be regarded as an essential part of the professional training of a Greek Revival architect. Before the end of the second decade of the nineteenth century, most remains of the classical Greek orders had been studied *in situ* by European scholars who, unfortunately, often combined professional expertise with an appetite for treasure hunting. Indeed, architectural and archeological research in Greece led unavoidably to official and unofficial excavations and consequently to the rape of antiquities, such as Lord Elgin's trophies from the Parthenon (cat. no. 4), the frieze from the Temple of Apollo Epicurius at Bassae, and the sculptures from the Temple of Apaia in Aegina (cat. no. 34).

A widespread passion for collecting, shared equally by antiquarians, art lovers, connoisseurs, scholars, and Grand Tourists, contributed to the lure of Greece in the first quarter of the nineteenth century. In addition, the

blockade of the Continent during the Napoleonic Wars prompted an increasing number of European travelers to choose Greece as their destination. Also during the first two decades of the century there appeared a great number of handsomely illustrated volumes depicting Greek monuments and scenery, such as those by Louis-François Cassas (cat. no. 10), Edward Dodwell (cat. no. 18), Sir William Gell (cat. no. 32), and Hugh William Williams (cat. no. 41).

Although the majority of European visitors to Greece in the early 1800s were unappreciative of anything that had happened there since the age of Pericles, contemporary political and social developments in the Ottoman Empire and the flourishing of Greek diaspora communities in the major trade centers of western Europe (see cat. no. 63) prompted Europeans to reconsider their classical preconceptions of Greece and to direct their eyes upon its current inhabitants and their situation. Indeed, by 1820, various aspects of the Greek people's everyday life began to fill artists' sketchbooks (cat. nos. 9, 26, 45). Even in the travel literature of the period European writers began to speculate on the future of the enslaved Greeks. Politically motivated surveys compiled by official

Bazaar of Athens
Aquatint engraving
34.0 x 48.0 cm
Drawing by
Edward Dodwell
From Dodwell's
Views in Greece
(London, 1821)

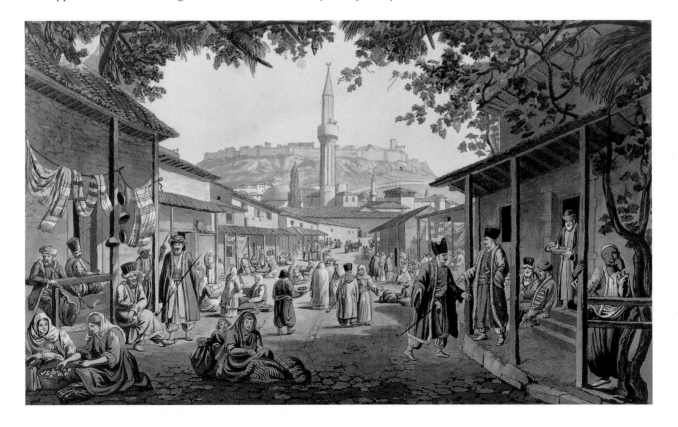

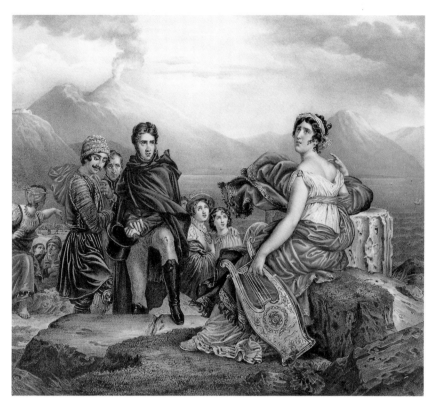

Chateaubriand and
Mme de Staël among
the Greeks
1827
Lithograph
25.5 x 29.5 cm
Drawing by H. L. J. B.
Aubry-Lecomte
Lithograph by Léon Noel
After the painting
Corinne au Cap Misène
by F. P. S. Gérard
Inv. no. 27874

representatives of foreign governments were published. Such concerns for Greece's future were greatly heightened when Lord Byron published *Childe Harold's Pilgrimage* in 1812. In it, Byron delineated to the general public the image of a Greece that was more than just a setting in which the classically minded traveler could revel. It became a vital country inhabited by brave and suffering people who deserved better lives.

Repercussions of liberty echoing from the French Revolution had been widely felt in Greece. Furthermore, the decline of the Ottoman Empire and the disorganization of its central government proved favorable to the Greek cause. Already in the early nineteenth century a new sense of national identity had emerged in Greece and played a catalytic role in the mounting of a coordinated insurrection. The Greek War of Independence broke out in the Peloponnese in March 1821 and spread simultaneously over to the Greek mainland and the islands. As news of the Greek uprising spread in Europe, philhellenic societies and committees were immediately formed in England, France, and Germany. Byron's death in Missolonghi in 1824 (cat. no. 57) transformed the philhellenic movement into a romantic crusade. "Will our century watch hordes of savages extinguish civilization at its rebirth on the tomb of a people who civilized the world? Will Christendom calmly allow Turks to strangle Christians? And will the legitimate Monarchs of Europe shamelessly permit their sacred name to be given to a tyranny which could have reddened the Tiber?" wrote Comte Chateaubriand in his *Note sur la Grèce* (1825).

Chateaubriand's queries touch upon the different aspects of philhellenism. The Greek cause was adopted by liberals, Christians, humanists, and classical scholars alike. It appealed to members of the British parliament, Swiss bankers, French workers, society ladies, German intellectuals, the royal family of Sweden, and the crown prince of Bavaria. Not just an intellectual cult, philhellenism was ultimately transformed into a popular movement.

Indeed, the Greek cause became the creed of every decent person in Europe. In the 1820s, books on Greece rolled off the presses, charity concerts were organized, plays were performed to aid the *palikars*, and exhibitions of pictures were held.

Greeks had hoped that the governments of Europe would bless their enterprise, but throughout the six years of their struggle distrust among the Great Powers of Britain, Russia, and later France frustrated a number of tentative interventionist proposals. Finally it was decided that collective action was needed if there was to be any stability in the eastern Mediterranean. On October 10, 1827, the allied forces defeated the Ottoman fleet at Navarino (cat. no. 68). Public opinion soared. Yet while the Battle of Navarino enormously strengthened the Greek position, it did not resolve the country's problems. In fact, the early years of the Liberation were an unhappy period for the infant Greek state. After the assassination of Governor Ioannis Capodistrias in 1831 (cat. no. 69), the Great Powers selected Prince Otho of Bavaria as king of Greece (cat. no. 70).

The first independent Greek state consisted of only part of the mainland and a few of the Aegean Islands (see map, p. 23). Crete and the regions of Epirus and Macedonia were excluded. Despite the lack of a written constitution as such until 1843, a civil service was in place, and order was maintained by an army of 5,000 troops recruited in Bavaria. The young king had high hopes that the muses of the classical spirit would return to Greece, and he enthusiastically undertook the task of presiding over the creation of a new Hellas based on European models. The challenge of contributing towards this transformation attracted many Europeans, who in the 1830s and 1840s created a hive of archeological, architectural, and artistic activity in Greece. Politically, however, Othonian Greece was characterized by instability and continuous competition among the Great Powers for the role of patron of the Greeks. This restless political situation, which greatly accounted for the country's loss of popularity among European visitors at that time, finally led to Otho's deposition in 1862 and to the enthronement of another European prince, George of Denmark, who was nominated king of the Hellenes in 1863. The Greeks were delighted. Thanks to the change of dynasty, the Ionian Islands were returned by the British, and European tourists revived their exploration of the picturesque possibilities of Greece.

Throughout Otho's reign, and following the installment of a new leader, those visitors from the Continent who ventured to Greece were charmed by the picturesque contrasts of a country on the crossroads of East and West. Poised on the threshold of the Levant, Greece became a staging post for Orientalists on their way to more

exotic Eastern lands, which towards the mid-1800s were tantalizing the European imagination. Nevertheless, by then the scientific exploration of the ancient world had attained such impetus that current shifts of taste could not halt it. Excavations conducted by Heinrich Schliemann at Mycenae and Tiryns during the 1870s and 1880s revealed hidden aspects of Greek antiquity, and systematic digs were undertaken by European archeological schools throughout the last quarter of the nineteenth century. This scientific approach occurred simultaneously with a more popular assimilation of classicism. The classical consciousness of Europeans was renewed in large part thanks to the pictorial world invented by classicist artists, who provided a spectacular reconstruction of daily life in ancient Greece.

In reviewing works of Greek subjects, the fact that these images seem to have been largely tinted by an intellectual process is striking. This is quite understandable, because to most people Greece engenders a variety of often contradictory attributes that may be encompassed under the definition "a Romantic country." Such Romantic qualities were even more noticeably emphatic in the 1800s, when the country's appearance was not yet marred by the excrescences of industrialization. To Europeans, the powerful influences of tradition, literature, and history were such that Greece was perceived as an ideal rather than as a real country. Therefore, in their use of Greek imagery, European artists employed both the region's pictorial qualities and its literary connotations. Not only did they attempt to record the country topographically and to express their individual responses to its nature, but they also employed it as a means to recreate a sense of nostalgia for a bygone age and to satisfy the literary imagination. For those who could claim firsthand experience of the country, such images evoked familiar emotions and memories. For the armchair traveler, they filled a need for visual documentation of popular destinations and fed appetites craving colorful, picturesque scenery. They provided visual supple-

Women of the
Island of Sifnos
Engraving
18.0 x 25.0 cm
Drawing by
Jean-Baptiste Hilair
Engraving by
A. J. Duclos
From Choiseul-Gouffier's
Voyage Pittoresque
de la Grèce
(Paris, 1782-1822)

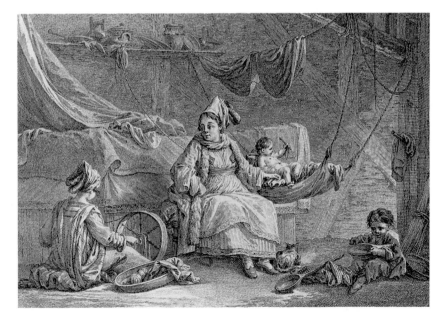

ments to archeological information, put forward a historical comment, or perpetuated heroic actions and events. Indeed, the variety of pictorial conventions employed in these works may be indicative of Europeans' changing attitudes towards Greece. Above all, it suggests a gradual development from a basically archeological interest to a Romantic evocation of the country's emotional and intellectual associations and its graphic aspects.

European neo-classical interest in the delineation of ancient Greek structures extended to the depiction of the scenery within and around the classical ruins. Artist-travelers hastened to Greece with the aim of satisfying public appetite for visual evidence of its scenery. Yet this was an imagined Greece, one mythologized to their expectations. "There is nothing in our visit resembling the introduction to a new circle of acquaintances; it is the revived delight of the society of long absent and beloved friends."[1] Thus wrote the British artist and poet William Haygarth when he stepped onto Greek soil in 1810, eloquently expressing the fact that European visitors to Greece were fully equipped with an illusionary, preconceived image of the country. Such notions presented a challenge to the artist. Although similar in some ways to the problem of depicting Italy, capturing Greece on canvas involved additional difficulties. Magnificent specimens of architecture and a paradisiacal countryside still existed in nineteenth-century Italy. In

Greece, however, long periods of war and foreign domination had resulted in the impoverishment of both its people and landscape. Artists often preferred to avoid rendering the sorry state of the great cities of the past and instead attempted to evoke "the spirit of the place." They frequently resorted to using such convenient formulas for the pictorial combination of nature and classical remains as those employed by Claude Lorrain and Nicolas Poussin. One outstanding representative artist of ideal Greek landscapes is the painter "Grecian" Williams (cat. no. 48), whose dignified compositions of dramatic and imaginative nature present a world that borders between dream and reality.

Summoning the romance of Greece characterizes most nineteenth-century images, even those by artists whose works reveal a less fanciful approach to the landscape. (See, for example, works by Raffaelo Ceccoli [cat. no. 2], Rudolph Müller [cat. no. 3], Louis Dupré [cat. no. 9], Thomas Hartley Cromek [cat. no. 11], and Vincenzo Lanza [cat. nos. 14, 16].) Nevertheless, their attempts to invest scenes with an allegorical significance made their Greek images appealing to the literary as well as to the romantic imagination.

In the 1820s, the Greek War of Independence provided European artists with a wealth of themes. Pictorially, the heroic, religious, classical, and oriental elements of the revolution offered them particularly sensational subject matter.

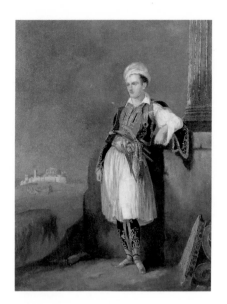

Lord Byron in Athens
ca. 1840
Oil on canvas
96.0 x 74.0 cm
Artist unknown
Inv. no. 1100

Furthermore, the theme was so familiar to the European public that artists utilized it to allude to the oppression in their own countries (cat. nos. 56, 60). While the Greek War inspired Romantic minds and hearts all over Europe, it was mainly through Byron's poetry that contemporary Greece was revealed to most European artists. In his verses the poet had succeeded in blending the classical elements and vibrant Eastern colors of Greece with its reality. By putting forward a new image of a passionate, living world rich in associations, Byron shattered the European vision of a timeless Greece. His victorious *giaour*, brave *palikars*, and mysterious Greek maids chased the mythological heroes and ancient nymphs from the Greek pictorial repertoire.

This is not to say that classical allusions disappeared from imagery of the Greek War altogether. They continued to be broadly used, but in a new context. The Greeks' classical heritage and references to it became a uniting force, and they defended that legacy with a heroism worthy of their ancient forefathers. Greeks were often depicted fighting amongst classical ruins, expiring with the same dignity as their heroic ancestors (cat. no. 65), or posing as stalwart figures with handsome faces and classical noses (cat. nos. 21, 25). At the same time, the religious overtones of the Greek cause were as powerful as the classical. "The

Iphigenias of modern Greece are those Christian virgins, who kill themselves rather than surrender," so thought the classically educated Europeans of the 1820s.[2] Greeks were lamented as modern martyrs of the Christian faith. "When considering that there have been so many infamous acts on the part of the Turks and so much suffering on the other, one begins to wonder if there are more Muslim powers in Europe than Christian," declared the French artist Louis Dupré.[3] Scenes of venerable priests being humiliated, profanations of holy reliquaries, and ferocious Turks eager to rape Christian virgins roused the wrath of Christianity against the infidels. The presence of such motifs on religious banners and icons (cat. nos. 57, 67) fired the souls of European viewers.

For the larger public the struggle of the Greeks was sensational and infinitely romantic. Certainly Romantic artists were moved more by the tragedies of the Greek revolutionaries than by their achievements. It was usually the failures and the dramas of the Greeks they chose to record, such as *The Death of Marcos Botsaris* (cat. no. 56), *Missolonghi Fugitives* (cat. no. 58), or *Scene from the Evacuation of Parga* (cat. no. 60), rather than their triumphs. Most philhellenic pictures reveal not only artists' attraction to the historical contemporaneity of the specific events, but also their fascination with the emotional, melodramatic, and exotic potential of such subject matter. Indeed, most Greek scenes of this nature embody a wealth

of Romantic implications, such as patriotism, moral virtues, and exaggerated personal emotions (cat. nos. 59, 61, 65).

The most popular Greek themes became widely known through reproduction in a variety of media. Lithographed sets of portraits of Greek leaders and eminent philhellenes were commissioned by philhellenic committees in Switzerland, Germany, France, and Britain (cat. no. 63). Printed images of events described in the newspapers sold readily all over Europe. The Greek War presented artists with unlimited material for often trivial scenes. European shop windows were filled with series of prints entitled "The Dying Greek Warrior" or "Palikars Bidding Farewell to Their Families," in which many of the unfortunate Greeks expire in the most operatic postures.

Beyond engraving and lithography, philhellenic images were reproduced in all kinds of applied arts. Jean Zuber's wallpaper factory in Rixheim issued a set of panoramic paper, "Vues de la Grèce moderne, ou Les Combats des Grecs," showing a pastiche of popular Greek paintings of the day. Philhellenic dinner sets, wine flasks, flower vases, embroideries, fans, firescreens, table clocks, statuettes, ink stands, jewelry boxes, and tobacco cases, all bearing representations of wounded palikars and persecuted Greek maids, were sold at charity bazaars. Commercially minded professionals of all trades offered philhellenic items. The "Nectar of the

Victorious Greeks," invented by a French wine seller, did wonders for the spirits of European philhellenes. "Missolonghi gray" became the fashionable color of the philhellenic high society. A jeweler in Paris created "In aid of the Greeks" brooches in the shape and colors of the Greek flag, and a German confectioner sold cakes decorated with philhellenic couplets. No matter how kitsch many of these products may now appear, such efforts undoubtedly kept Greece in the forefront of European public opinion, whose moral and material support helped to ensure a Greek victory.

Within weeks of the triumphant Battle of Navarino, illustrations of the event poured off lithographic presses. Europeans were delighted, and masses of spectators crowded into the panoramas of "The Battle of Navarino" that were exhibited in London and Paris. The creation of the new Greek state and King Otho's enthronement further enriched the artistic repertoire on Greece. While historical scenes of the revolution and portraits of its heroes continued to attract artists, in many cases they were used merely as an excuse for studies of foreign costumes and miscellaneous exotica. Of course, by then the Greek struggle was no longer a contemporary event, and as memory dimmed, historical representations became stereotyped and mannered.

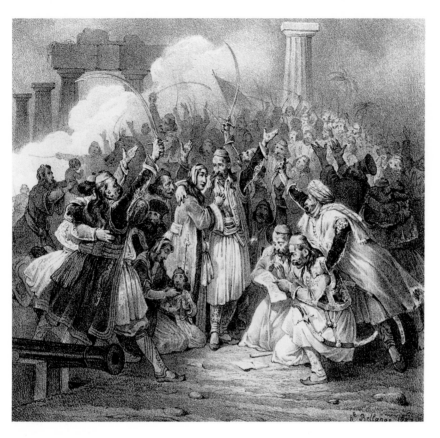

Greeks Receiving
the News of the
Battle of Navarino
1827
Lithograph
20.0 x 22.0 cm
Drawing and lithograph
by J. L. H. Bellangé
Inv. no. 26380

The 1840s and 1850s witnessed Europe's Great Age of Travel, when middle-class tourists could easily wander throughout and around the Continent by rail or steamship in search of alluring locations. Numerous illustrated travel books on Greece produced during this time provided readers with appropriately pictorial specimens of a country rich in contrasts, with ancient place-names, Eastern features, Western architecture, exotically dressed inhabitants, sunny shores, picturesque sites—and European-style facilities. European artists hurried to fill their portfolios with a wealth of features

based upon the Romantic vocabulary that characterized the appearance of Greece in the mid-1800s: "gay and gilded Greeks" in intricate costumes (cat. nos. 24, 27), ruined classical temples crowned with weeds, Byzantine churches, Islamic mosques, neo-classical public buildings, tumble-down houses, olive groves, and palm trees (cat. nos. 5, 7, 12). A number of artists during the same period showed less concern with the pleasurable, scenic side of Greece, and instead attempted to describe their own personal vision or experience of the country. Their Greek images embody a set of Romantic ideals that excite the imagination and lead to reverie (cat. nos. 3, 11, 16). Executed in a manner appropriate to Romantic sensibilities, they represent familiar Greek locations invested with an intensity that suggests a personal dialogue through their imaginative nature and highly poetic mood.

If European artists were concerned with authenticating classical myth and legend in 1800, by the 1850s and 1860s their interest had shifted towards Biblical topography. During those decades Athens was deemed less attractive than Constantinople, Cairo, or Jerusalem, and the classical ruins of Greece were viewed as curiosities. The revival of specifically religious subject matter in art, together with a growing interest in Byzantine studies throughout Europe, led to a re-evaluation of the surviving Byzantine monuments in Greece, which had been largely ignored until then (see cat. no. 17). In the

words of the British artist-traveler Mary Hogarth, "A foreign visitor to Greece will often return to its medieval churches, when tired from the shattered grandeurs of a dead past, or the imperfectly realised pretentions of the present."[4]

In the late nineteenth century, while the Oriental aesthetic was gaining ground on the Continent and shifts in taste arrested European interest in Greece, classicist artists "rediscovered" the heroic era and presented to the European public a colorful reconstruction of the ancient Greek world. In a period of rapid industrialization and changing values, European classicists offered viewers an enchanting refuge in phantasmagoric Greek scenes. These well-staged "records" of daily life in ancient Greece, set in exquisite classical interiors with brilliantly polished surfaces, were peopled by handsome youths attired in stylized draperies and gracefully modeled, amorous girls. Such imagery was soon demythologized by the emergence of more realistic notions in European art. Moreover, the trivialized assimilation of classicism collided with a more scientific approach to ancient Greece. The French Archaeological School in Athens was founded in 1846, the German in 1874, the American in 1882, and the British in 1885. Concurrently, numerous publications discussed the recently excavated centers of the ancient Greek world. Thus, as European intellectuals and artists gradually abandoned their efforts to romanticize Greece, more complex perspectives on the study of Greek antiquity were evolving. The classical yardstick ceased to be the only measure of Greece's participation in European affairs.

The uncommonly wide span of its history, the awareness of its unparalleled glorious past, its people's heroic struggle for freedom, the country's rebirth with the aim of regaining its ethnic identity and safeguarding its cultural heritage: these are some of the notions that in the nineteenth century invested Greece with the aura of a Romantic land. Throughout the 1800s Greece was indeed a fertile source of romance of European artists. The abundance of existing works by them confirms the country's prevailing appeal. Artists were lured by the gigantic associations of its past, haunted by an idyllic classical vision, or drawn by the liberal aspects of its revolutionary struggle. The variety of pictorial conventions employed in these images provide eloquent evidence of aesthetic and stylistic predilections. In a broader sense, they also significantly elucidate some artistic as well as historical and ideological facets of the nineteenth century.

Dr. Fani-Maria Tsigakou
Curator of Paintings,
Prints and Drawings,
Benaki Museum

[1] W. Haygarth, *Greece, A Poem in Three Parts, with Notes, Classical Illustrations and Sketches of the Scenery* (London, 1814).
[2] R. Canat, *La renaissance de la Grèce antique (1820-1850)* (Paris, 1911), 13.
[3] Ibid.
[4] M. Hogarth, *Scenes in Athens drawn and tinted by Mary Hogarth, described by David Hogarth* (Oxford, England [1890]).

A Journey
to Greece
in the Nineteenth
Century

Most nineteenth-century visitors to Greece started their tour of the country from Athens and Attica. Athens was of prime interest due to the attractions it provided in itself and its convenience as a starting point for tours of the rest of the country and the adjacent islands, i.e., Salamis, Aegina, and Poros.

Travelers' second choice was the Peloponnese. This leaf-shaped peninsula, which extends southwards from the Isthmus of Corinth, offered visitors endless opportunities to enjoy an enchanting natural scenery and to indulge in Greece's long history by wandering through Corinth, Argos, Sparta, Mistras, and Paras, from where they could sail to the Ionian Islands. These islands forming the Septinsular republic were Corfu, Paxos, Leucas, Cephalonia, Ithaca, and Zante, which lie in a chain opposite the coast of lower Albania, the Greek province of Epirus, and the island of Cythera, situated opposite the southern coast of the Peloponnese.

Travelers coming from the Ionian Islands would cross the coast of Epirus to visit Parga, and then continue southwards to the plains of Thessaly and Attica. From there they could take excursions to the popular sites and towns of the mainland, i.e., Thebes, Levadia, Delphi, and Mount Parnassus. Those who wished to venture beyond these conventional itineraries could undertake a cruise among the islands of the Aegean Sea. Most of the Aegean Islands could be reached by boat from Piraeus.

The usual manner of transportation in the interior of the country was on horseback. One of the most vivid descriptions of the discomforts awaiting the traveler was written by Edward Lear. "Then we reach some village where any house does for our night's dwellings—for little iron bedsteads with mattresses are put up directly and on these a large muslin bag tied to the ceiling; into which I creep by a hole, which is tied up directly I am in it, so that no creature gets in, and one sleeps soundly in a room full of vermin" (*Journals of a Landscape Painter...*, London, 1851).

While in most Greek towns travelers were received at the foreign consulates, the common accommodations throughout the country were inns (*khans*, in Greek). The inadequacies of these khans were eloquently summarized by Lear in his invention of the characteristic pun, "Khan, it is called, because you *Can't* sleep!"

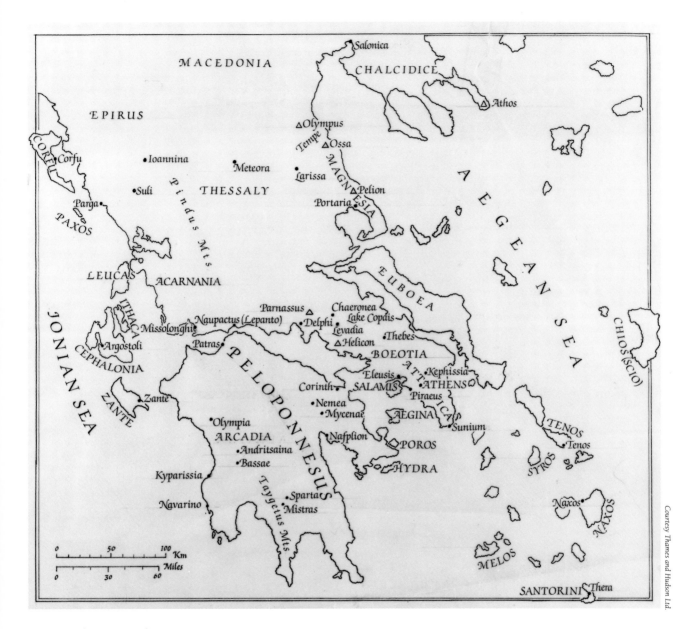

Greece in the nineteenth century

A Greek Mountaineer
(cat. no. 28)

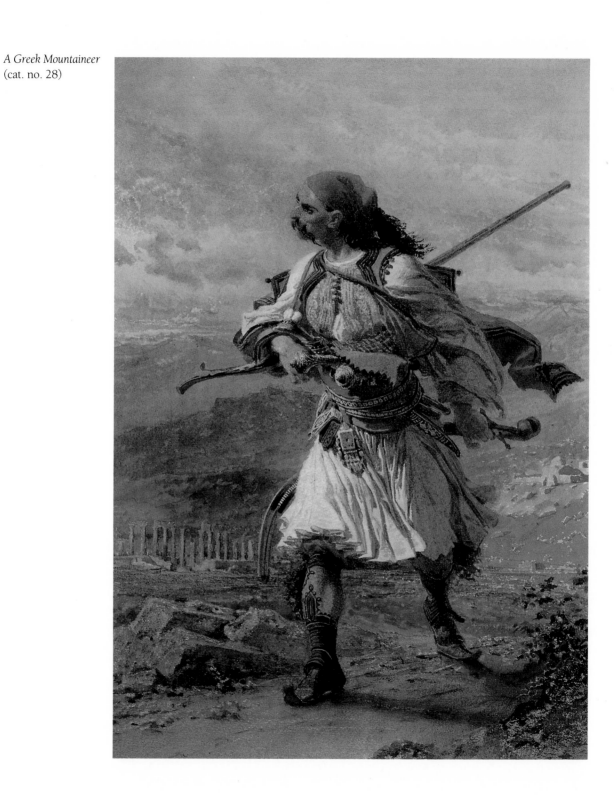

Catalogue of Works

1. VIEW OF ATHENS FROM THE PHILOPAPPUS HILL
Ca. 1820

Richard Banks Harraden
(1778-1862)
Oil on canvas
49.0 x 86.0 cm
Inv. no. 11192

"Even if Athens should be totally abandoned, it will live on in the minds of posterity as a more glorious and powerful city than Sparta thanks to its sanctuaries and monuments." So wrote the Athenian historian Thucydides in the fifth century B.C., and his prophecy has come true. The city of Pallas Athena, despite being wracked by one calamity after another, has survived for many centuries as a symbol of artistic excellence. Representing the pagan spirit, Athens declined with the triumph of Christianity. Turkish rule in Athens itself began in 1456/58, after which the first city of Greece sank into oblivion until the mid-seventeenth century, when it was rediscovered by western European travelers. Their written and pictorial records preserve valuable information about the city's topography and life.

Richard Banks Harraden's view is taken from the Hill of the Muses (or Mouseion) overlooking the southeastern side of the Acropolis. Part of the Philopappus Monument that crowns the Mouseion is shown in the far left foreground. This painting gives a fairly clear idea of the appearance and size of Athens in the early years of the nineteenth century. As in antiquity, so too was Athens divided into two parts in the Turkish period: the Acropolis, which was called Kastro (castle), and the lower city. The Acropolis was no longer the shrine of Athena but instead served as the headquarters of the commandant of the Turkish garrison. The soldiers' quarters can be seen inside the Acropolis. Also visible is the Turkish wall around the Acropolis, which incorporates the Theater of Herodes Atticus clearly depicted at the foot of the southern slope. The so-called Haseki, or city walls, which were constructed in 1778, are also shown.

By selecting this view, Harraden offers an adequate impression of Athens as a small town characterized by narrow, winding streets and buildings packed closely together. A close look reveals various types of houses, ranging from simple stone structures to arcaded buildings. Many mosques are scattered throughout the city.

Two famous ancient Athenian monuments, the Thesseion and the Olympeion, figure conspicuously on either end of the city. With remarkable perception, the artist captured what was then the most distinctive feature of Athens and certainly one upon which many Western travelers remarked, that is, the random juxtaposition of monuments from different periods, which provided a setting for an attractive pageant of the city's long history.

It is not known whether Harraden, a British landscape painter and engraver of topographical views, gathered his visual material on the spot, but his topographical and architectural details furnish a reliable record of Athens in the early years of the nineteenth century, before the Greek Revolution. The attribution of this painting to Harraden is confirmed by the fact that the Museum of the City of Athens possesses another version of this subject with slight alterations to the figures in the foreground. That oil painting is inscribed "R. B. Harraden pinxit Oxford 1830."

Reference
Samuel Redgrave, *A Dictionary of Artists of the English School* (London, 1970), 198; *Athens from the end of the ancient era to Greek Independence* (exh. cat.; Athens, 1985), 12-20, 28-35.

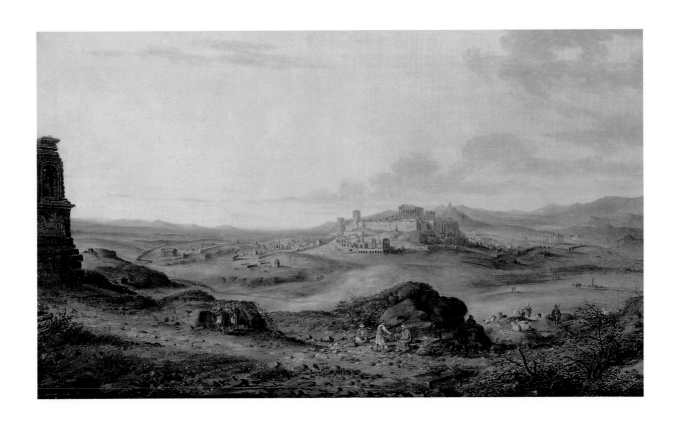

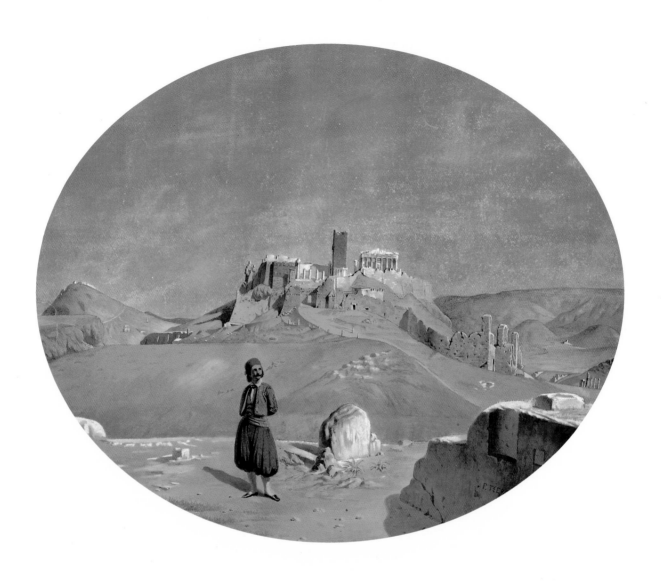

2. VIEW OF THE ACROPOLIS FROM THE SOUTHWEST Ca. 1850

Raffaelo Ceccoli
(act. mid-19th century)
Watercolor on paper
44.5 x 59.5 cm
Signed (in Greek):
R. Ceccoli
Inv. no. 23423

The Acropolis of Athens is a true natural fortress occupying an area of about 270 by 156 meters (886 by 512 feet). Perhaps in no other part of the world and in so relatively small an area has such a remarkable collection of architectural and sculptural masterpieces been concentrated. This strong image of a fortress immediately strikes the viewer upon looking at its high walls from the southwest side. Raffaelo Ceccoli appropriately chose this side, for it also allowed him to display more effectively the harmonious ensemble of grandiose monuments that resulted from Pericle's stupendous construction plan.

The artist depicts in great detail the Propylaea, a majestic vestibule on the western slope of the Acropolis, which underwent drastic changes during the periods of Frankish and Turkish occupation and was being restored throughout the second half of the nineteenth century. Access to the Acropolis was originally through the Propylaea, but in 437-432 B.C. this principal entrance suffered damages and modifications, including its conversion into a Frankish palace during the fourteenth century, when a high, square tower was added. This red brick tower, which was demolished in 1875, figures prominently in the middle of the western facade, near the small Temple of Athena Nike. The Turkish gateway to the area, a vaulted passage known as the Tholikon, is also perceived lower down to the right, along the medieval wall. At the foot of the southwestern slope, the facade of the Theater of Herodes Atticus, which is flanked by semicircular arches in red brick, contributes a picturesque touch to the solemn sight of the Acropolis. Ceccoli rendered this view with an almost archeological consciousness. Yet what is remarkable about this watercolor is the way the artist captured the specific quality of Athenian light: the luminous "violet" for which Athens was renowned and which inspired Aristophanes to describe her as being "crowned with violets."

The Neapolitan painter Ceccoli resided in Greece between 1840 and 1855, and he taught at the School of Fine Arts in Athens (1843-52). He painted landscapes and portraits, mainly of the heroes of the Greek War of Independence.

Reference
A. S. Ioannou, *Greek Painting: 19th Century* (in Greek; Athens, 1974), 30; S. Lydakis, *Dictionary of Greek Painters* (in Greek; Athens, 1976), 441; F.-M. Tsigakou, *The Rediscovery of Greece: Travellers and Painters of the Romantic Era* (London, 1981), 201.

3. VIEW OF THE ACROPOLIS FROM THE PNYX 1863

Rudolph Müller
(1802-1885)
Watercolor on paper
62.5 x 87.5 cm
Signed and dated
(bottom right): Rud.
Müller Rome 1863
Inv. no. 25193

The site from which this view is taken is known as the Pnyx, which means "a place tightly crowded." Closely associated with the history of ancient Athenian democracy, the Pnyx was where the People's Assembly (Ecclesia), the most important civic body of the ancient Athenian state, held its sessions. This natural rocky terrace facing the Acropolis forms a platform of three steps, clearly depicted in the foreground, which served as the tribune on which ancient orators stood to address the people.

This partial view shows the western side of the Acropolis and, on the left, part of the city. It also offers a reliable record of Athenian houses, most of which are of a simple two-story design typical of the first period of neo-classicism in the city, in addition to some of the Othonian public buildings, such as the royal palace, which was completed in 1842. In the background the mounts and hills of Attica are carefully arranged—Lycabettus Hill on the left, Mount Hymettus in the middle, and in the far distance Mounts Parnes and Pendeli—all set against a limpid, violet sky.

Rudolph Müller caught both the grandeur of the site and the translucent atmosphere of Attica. Moreover, he carefully selected his tonal effects to invest the picture with an allegorical significance. The Acropolis, rising like a golden mass from the darkly shadowed and solemn Pnyx to dominate the city below, alludes to a Romantic vision of the Acropolis as the glorious expression of creative genius that emerged from the combination of ideal cultural, social, and political conditions.

Little is known of Müller, a Swiss landscape painter who traveled extensively in the Mediterranean before he finally settled in Rome after 1860. It was there that he painted this view after the drawings he had made on the spot.

Reference
E. Benezit, *Dictionnaire critique et documentaire des peintres, sculpteurs, dessinateurs et graveurs* (Paris, 1976), 7:599 (referred to as Benezit); U. Thieme and F. Becker, *Allgemeines Lexicon der bildenden Künstler von der Antike bis zur Gegenwart*, 36 vols. (Leipzig, 1908-74), 25:247 (referred to as Thieme-Becker).

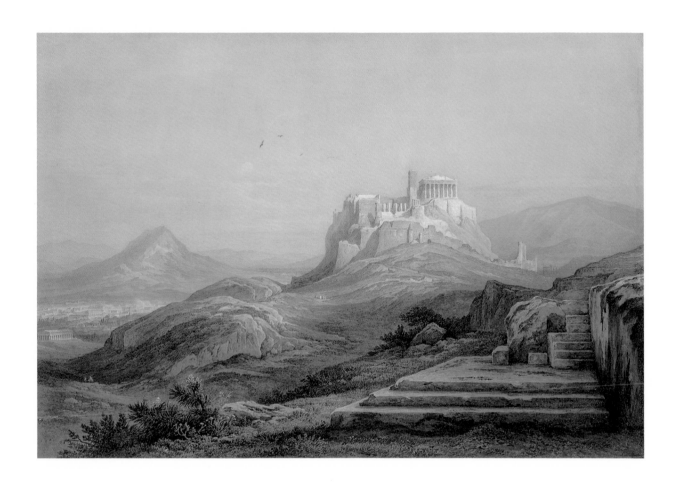

4. VIEW OF THE PARTHENON 1802

*Giovanni Battista Lusieri
(1751-1821)
Watercolor on paper
58.0 x 95.0 cm
Inv. no. 23979*

Throughout its long history the fortunes and fame of Athens have remained inextricably linked to the name of its divine patroness Athena and her splendid shrine, the Parthenon. Built in 447-432 B.C. by the architect Ictinus under the general supervision of Pheidias, the Parthenon was destined to be an imperishable monument dedicated to the city's grandeur. This Doric temple perfectly combines ingenious architectural design and stupendous sculptural decoration.

While glorified by its admirers, the Parthenon suffered violent destruction by foreign invaders. During the Veneto-Turkish War, the central part of the building was destroyed by a bomb in 1687. Francesco Morosini, the commander in chief of the Venetian forces, defaced part of the western pediment in an attempt to plunder its statues. For two thousand years the Parthenon had resisted the passage of time and the ravages of human wantoness, before it suffered a catastrophy unparalleled since the Persian Wars. The way to its pillaging and plundering lay open.

In September 1799, Thomas Bruce, seventh earl of Elgin, had been sent as the English ambassador to Constantinople, and he immediately started making preparations for his plan "to make his embassy beneficial to the progress of Fine Arts in Great Britain." A month later, W. R. Hamilton, Elgin's secretary, recruited the Italian painter Giovanni Battista Lusieri, court painter to the king of Naples, to head the mission for the removal of the Greek marbles. In August 1800, Lusieri was in Athens as Elgin's agent and as head of the expedition, which included another painter and two architects. Elgin's accomplishment in acquiring permission for his artists to work on the Acropolis was due to the current political situation in the Mediterranean. Napoleon Bonaparte's invasion of Egypt in 1798 had given the British government an opportunity to supersede France in the favor of the Ottoman Porte. It was after the successful British expedition to Egypt that Elgin had been awarded a firman by the sultan.

Lusieri arrived in Athens during the summer of 1800, and beginning in 1801 the Athenian marbles began to be taken down under his guidance. He stayed in the city long after the marbles had been shipped to England and made various tours in Greece with the purpose of acquiring antiquities. Almost all of the numerous drawings he made of Athens were lost at sea during the shipwreck of the *Mentor* in September 1802, which carried part of the Elgin Marbles. Lusieri died in Athens in 1821, only a month before the outbreak of the Greek Revolution, and was buried near the Capuchin monastery.

This view is taken from the northwest side of the Parthenon. Lusieri's watercolor remains a historical record of the utmost importance because it shows the Parthenon just after its despoliation. For example, on its western pediment, which represented the birth of Athena, only two figures survived on the spot: the torsos of King Cecrops and that of his daughter Aglavros. Most of the metopes, which originally depicted the battle of the Greeks with the Amazons, appear in a mutilated state. In pictorial terms Lusieri created an image that is both accurate and appealing to the literary imagination. By using delicate, translucent washes he effectively rendered the rusty texture of the marble surfaces and transformed the monument into an eerie sanctuary, rich in Romantic associations.

Reference
Benezit, 7:24; A. H. Smith, "Lord Elgin and his collection," in *Journal of Hellenic Studies* 36 (1916): 173-75; W. St. Clair, *Lord Elgin and the Marbles* (London, 1967); Tsigakou, *Rediscovery*, 191.

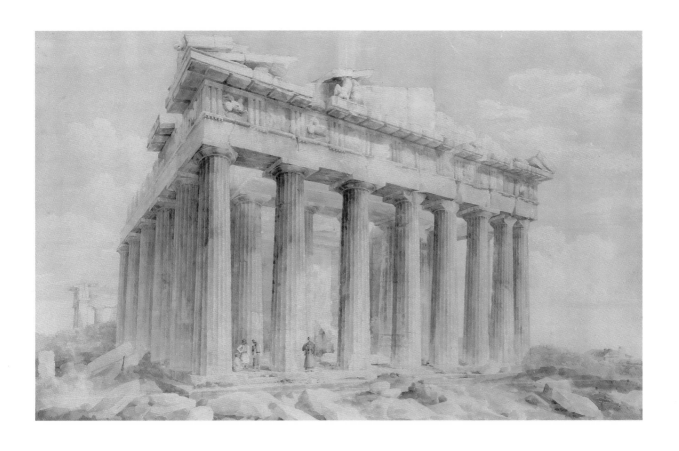

5. **VIEW OF THE PARTHENON WITH THE MOSQUE**
Ca. 1838-39

Jean Nicolas Henri
de Chacaton
(1813-after 1857)
Watercolor on paper
23.5 x 33.5 cm
Inv. no. 23969

Here, the French artist Jean Nicolas Henri de Chacaton allows the observer to view the Parthenon from the northwest and to study its architectural type. It is a peripteral temple (i.e., entirely surrounded by an exterior colonnade), with Doric columns that stand on a base. The temple's lavishly decorated interior had already been totally devastated by the beginning of the nineteenth century. Part of the Erechteion is shown at the extreme left of the composition.

In the fifth century A.D., following a series of Byzantine decrees that ordered all pagan sanctuaries to be purified, the goddess Athena was superseded by the Virgin Mary, and the Parthenon was transformed into the Church of Our Lady of Athens. In 1458, when the Turks captured Athens, Sultan Mohammed II (the Conqueror), who visited the city, ordered that the Parthenon be turned into a mosque.

The fatal blow came during the Veneto-Turkish War of 1687, when the temple, which was used by the Turks as storage for ammunition, was hit by a bomb and ripped wide open. The whole interior and the greatest part of its colonnade exploded into the air. A few years later the Turks built a new mosque on the site, which survived until the nineteenth century. That one—a plain, cubical building with a few arched windows roofed with a heavy dome—is shown here inside the temple. After the Liberation and during the early years of the Acropolis' restoration, the mosque was used as a repository against theft of the antiquities that had been scattered over the Acropolis. The mosque was demolished only three years after Chacaton's visit in 1852.

In addition to being a reliable document, this watercolor was executed by Chacaton with great delicacy of touch and careful attention to tonal values, characteristics of his other Athenian views (cat. nos. 13, 15, 17). Chacaton stayed in Athens in ca. 1838-39 as the draftsman of the traveling party organized by the Honorable Mrs. G. L. Dawson Damer. Between 1835 and 1857, Chacaton repeatedly submitted to the Paris Salon paintings from Greece and the Middle East. The Benaki Museum possesses a considerable collection of his watercolors that show various views of Athens.

Reference
Benezit, 2:634; Thieme-Becker, 6:326; Tsigakou, *Rediscovery*, 69, 126, pl. XX; Mrs. G. L. Dawson Damer, *Diary of a Tour in Greece, Turkey, Egypt and the Holy Land* (London, 1841); A. Kokkou, *The Conservation of Antiquities in Greece and the First Museums* (in Greek; Athens, 1977), 161-70.

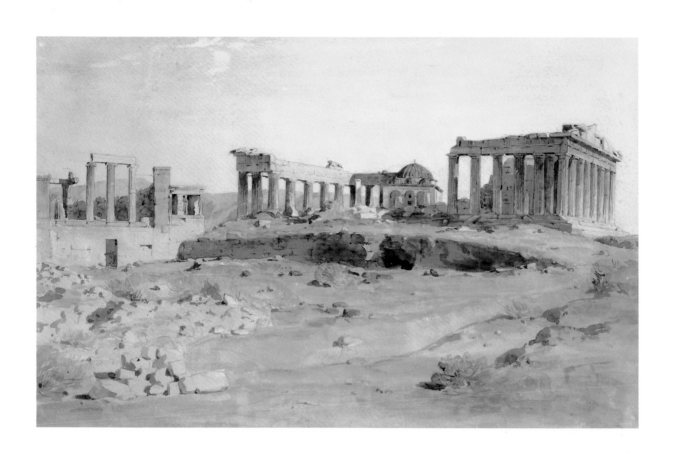

6. **A GREEK CONTEMPLATING THE VIEW FROM THE PARTHENON 1835-36**

Martinus Rørbye
(1803-1848)
Oil on canvas
30.0 x 40.0 cm
Inv. no. 17257

This rather unusual composition was conceived by the Danish painter Martinus Rørbye, a talented artist who was one of numerous Danish travelers to Greece, ranging from architects, artists, and classical scholars to the famous fairy-tale writer Hans Christian Andersen. During the Othonian period, many Danish archeologists and architects were involved in the restoration of works or the construction of public buildings in Athens.

Rørbye visited Athens for six months (late October 1835 through April 1836) as a prize-winning scholar of the Danish *Akademiet* (Fine Arts Academy). While in Greece, he kept a detailed journal, now deposited in the Royal Library of Copenhagen. Upon his first visit to the Acropolis, Rørbye noted in his journal, he was fascinated with the view it offered over the city and down to the sea and the plain of Attica. He was equally thrilled with the transparent light of the atmosphere and the colorful costumes of the Athenians.

All these elements are effectively revealed in this picture. This view is seen through the columns of the western porch: the Frankish tower rises on the right-hand side to overlook the Saronic Gulf and the island of Salamis. A man smoking his pipe stands in the foreground, where various marbles are scattered. His costume is carefully drawn, indicating the artist's particular interest in this subject. (In fact, the National Museum of Art in Copenhagen possesses a large set of Rørbye's Greek costume sketches.) The figure with his back turned to the spectator, seemingly lost in contemplating the scene, was a popular motif among Romantic painters. The artist invites the viewer to participate in the experience by placing the emphasis upon the landscape. While solidly modeling the coloring of his composition, Rørbye, a true Romantic artist, did not so much wish the observer to recognize this famous site but rather to share his own enchantment with the Athenian sky and light, and to convey the charm of an open-air scene. The attribution of this painting to Rørbye is confirmed by an identical oil painting, signed and dated, in a private collection in Denmark.

Reference
Benezit, 9:42-43; D. Helsted, et al., *Martinus Rørbye, 1803-1848* (Copenhagen, 1981); A. Papanikolaou-Christensen, *Athens 1818-1853: Views of Athens by Danish Artists* (Athens, 1985), 19-20, 25, pls. 192-217.

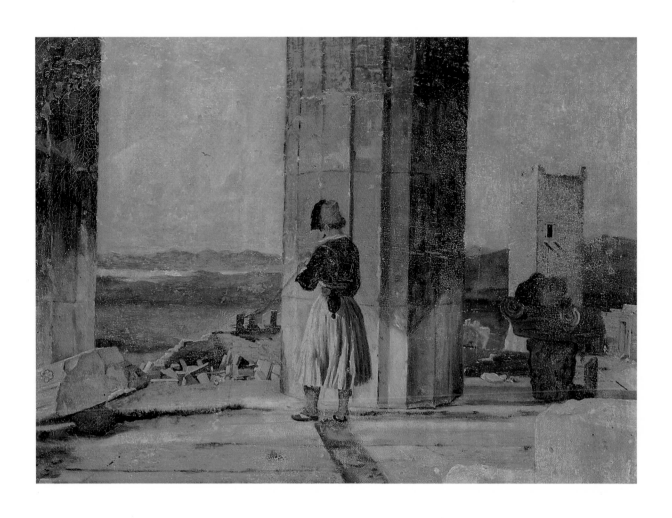

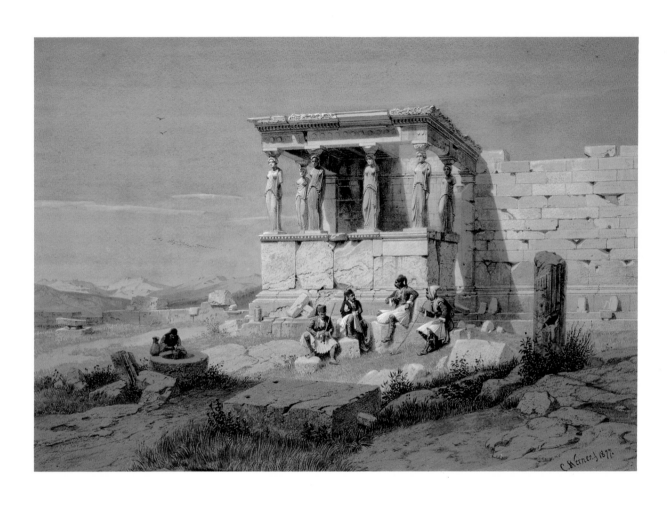

7. **VIEW OF THE PORCH OF THE CARYATIDS ON THE ERECHTEION 1877**

Carl Friedrich Werner
(1808-1894)
Gouache on paper
35.0 x 51.0 cm
Signed and dated
(lower right):
C. Werner, 1877
Inv. no. 23958

The Erechteion, or Sanctuary of Erectheus, was used as a temple, a tomb, and a center for divine mysteries. This assemblage of cult buildings was constructed in 421-406 B.C. on the most sacred part of the Acropolis, the site where Poseidon's mighty trident had left its marks and where Athena had caused her emblem, the olive tree, to sprout. It was seriously damaged during the Turkish occupation when it became the residence of the Turkish commandant, and it suffered further in the years of the Greek War of Independence, when its northern porch, which was used as a powder magazine, was blown up.

This view shows the porch on the southern section of the Erechteion, known as the Porch of the Caryatids (maidens), which constitutes an outstanding example of Ionic architecture. The Greek architect Mnesicles used as columns the statues of six *korai*, or caryatids. These female figures, with their air of grace and inner strength, provided the required support for the temple's entablature, which they seem to be carrying with effortless ease and solemn composure. In the words of a traveler contemporary to Werner, "Here Virgins attired in the religious costume of Panathenaic solemnity take the place of pillars and support the projecting cornice on their broad and sedate brows, which in that cornice seem rather to wear a crown than to sustain a burthen." One of the caryatids formed part of Lord Elgin's trophies (see cat. no. 4) and may now be seen in the British Museum in London. Werner depicted the porch thirty years after its reconstruction by the French architect Alexis Paccard in 1846-47.

The German landscape painter and lithographer Carl Friedrich Werner, a professor at the Academy of Leipzig, was established in Rome in 1850. In 1862 and again in the 1870s, he visited Greece and the Levant. The product of his oriental excursions were two lithographed folios entitled *Jerusalem, Bethlehem and the Holy Places* (1865) and *Carl Werner's Nile Sketches* (1871-75). In 1882, Werner wrote to the German archeologist Heinrich Schliemann in Athens, requesting him to provide a preface to an illustrated work that he was planning on the city. The book seems never to have appeared, but the list of plates intended for publication is included in Werner's letter, which is preserved in the Schliemann archive at the Gennadius Library in Athens.

In this gouache, as in *View of the Temple of Athena Nike* (cat. no. 8), Werner admirably used the descriptive possibilities of his medium. Concerned with realistic rendering, not only did he draw with touching exactitude the figures and their intricate costumes, but he also eagerly depicted geological and botanical details in the foreground. What distinguishes Werner's work is his high degree of technical accomplishment and his handling of marvelously intense colors.

Reference
Benezit, 10:700; Thieme-Becker, 35:404; L. Navari, *Catalogue of the Blackmer Collection* (London, 1989), 413, 419-20.

Also known as the Temple of the Wingless Victory, the Temple of Athena Nike was built in 427-424 B.C. on the western bastion of the Acropolis, on the site of an ancient cult of the goddess Athena. It stood at the foot of the Propylaea until 1687, when during a Venetian siege the Turks pulled it down to make way for a bastion (see cat. no. 4). Its former existence was brought to light thanks to the joint efforts of a team of archeologists and artists, including the Germans L. Ross and E. Schaubert and the Dane Ch. Hansen, who rebuilt the temple from its original components in 1835-36.

Wholly constructed of Pentelic marble, this architectural gem is a small Ionic temple with four columns on each end and is set on a podium with three steps. The sculpted representations on the frieze commemorate the victories of the Greeks over the Persians. Modern visitors can still admire most of the frieze, with the exception of a few panels that were carried away by Elgin. In his gouache, Werner capitalized on the scenic possibilities offered by the specific view. A sensitive colorist, he rendered the vibrant hues that play fleetingly on the walls and columns of the temple to emphasize its exquisite proportions and lavish decoration. He also captured the bright light over the Saronic Gulf, which lends the scene an air of classical serenity and enchantment.

Reference
Benezit, 10:700; Thieme-Becker, 35:404; Navari, *Blackmer Collection*, 413, 419-20.

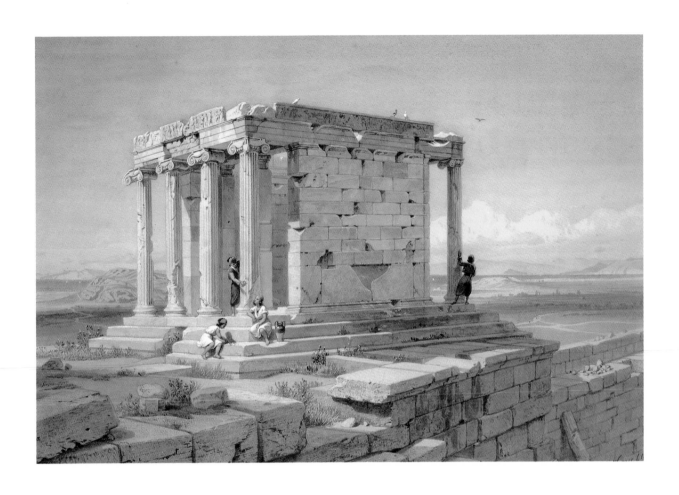

9. VIEW OF ATHENS WITH THE OLYMPEION 1819

Louis Dupré
(1789-1837)
Watercolor on paper
36.5 x 53.0 cm
Inscribed (in French):
View of Athens taken
from next to the ruins
of the temple of Ceres.
L. Dupré
Inv. no. 23001

This view of the Temple of Olympian Zeus (also known as the Olympeion), the Acropolis, and the houses clustered on its southeastern slope adequately represents the appearance of Athens before the War of Independence. Formerly referred to as Hadrian's Palace or the Pantheon of the Olympian Zeus, this colossal temple (the largest in Greece) was consecrated in A.D. 131-132 by the emperor Hadrian, a great benefactor of Athens. As seen in Louis Dupré's watercolor, the temple stands on an elevated terrace supported by a surrounding wall. Of its original one hundred four gigantic Corinthian columns, only sixteen survived in the nineteenth century. The temple was situated just outside the city walls, part of which can be discerned to the left, and incorporated Hadrian's Arch, which is slightly visible between the columns. The ruined brick construction perched on the left end of the temple's epistyle was a hut that in the early 1800s housed a stylite, a hermit living on the top of a pillar.

The view is taken from the banks of the Ilissus, a sacred river for Athenians that flowed by the southeastern side of the temple. On its shore sprang the Kalliroe fountain, where Athenian maidens went to fetch water for their nuptial baths. It is interesting that this custom had endured to the time of Dupré's visit, for he recorded that upon arriving at the site he saw "pots filled with honey and almonds that some Athenian girls had placed on the eve of their wedding day." According to the artist's inscription on the left side of this work, he drew the scene from the ruins of the Temple of Demeter. Later identified as the Temple of Artemis Agrotera, these ruins were the remains of a temple that had been converted into a church and consequently razed by the Turks in 1787 to be used as building material for the construction of the city walls.

Dupré ranks among the most gifted of the French artist-travelers who visited Greece before the War of Independence. A pupil of Jacques Louis David and an ardent admirer of classical Hellas, he toured Greece in 1819, and six years later he published a marvelous folio of colored lithographs with views and scenes from Greece entitled *Voyage à Athènes et Constantinople*. This scene is similar to *The Temple of Olympian Jupiter in Athens and the Acropolis*, plate 22 in Dupré's folio. According to the folio's introduction, the view was painted on April 16. In that text, Dupré also mentions that when he arrived in Athens he was disappointed "at the sight of the ugly walls that enclose such masterpieces." His sole consolation was that "the sun rays gilding the columns of the ancient sanctuaries bring to life the city of Pallas," as they do in this watercolor. By eliminating unnecessary details and enveloping the view in a transparent, delicate blue light, Dupré revealed the lyricism of the site.

Reference
Benezit, 4:44; Thieme-Becker, 10:177-78; Tsigakou, *Rediscovery*, 99, 191, 195; Navari, *Blackmer Collection*, 113.

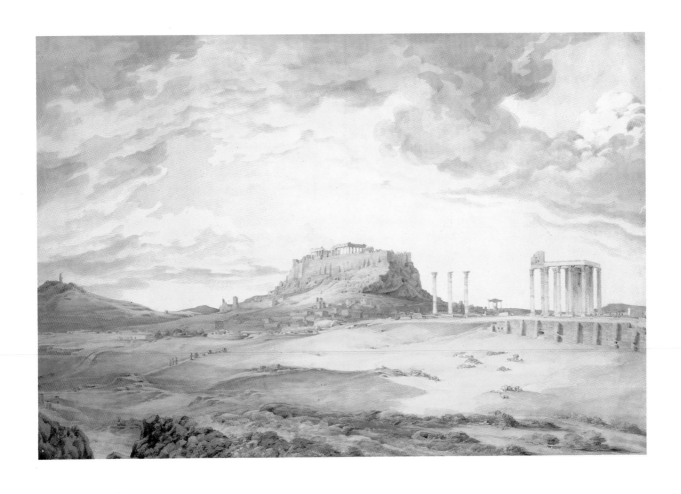

10. VIEW OF THE PHILOPAPPUS MONUMENT Ca. 1795

Louis-François Cassas
(1756-1827)
Watercolor on paper
44.0 x 50.0 cm
Inv. no. 23988

The Monument of Philopappus stands on the top of the Mouseion hill, which rises opposite the Acropolis (see cat. no. 1). This elegant Roman funerary monument was erected by the Athenians in A.D. 114-116 in honor of Gaius Julius Antiochus Philopappus, an exiled Roman prince and benefactor of Athens. His statue may be discerned inside the niche on a base adorned with a frieze. A landmark of Athens, the Philopappus Monument was popular with visiting artists because of its fine sculptural ornamentation and the commanding views one could obtain of both the Acropolis and the surrounding area. The monument is described in great detail in *The Antiquities of Athens Measured and Delineated* (1762-1816) by James Stuart and Nicholas Revett.

Towards the end of the eighteenth century the mounting lure of antiquity led to the publication of monumental folios that illustrated classical ruins. Louis-François Cassas, a French landscape painter, accompanied Count Marie-Gabriel-August-Florent de Choiseul-Gouffier to his embassy in Constantinople in 1784, but he remained there briefly. The artist traveled in Greece and the Levant at Choiseul-Gouffier's expense until 1787, making numerous drawings. In 1813, in collabortion with J. M. S. Bence, Cassas published a folio of aquatints entitled *Grandes Vues pittoresques des principaux sites et monuments de la Grèce et de la Sicile et des Sept Collines de Rome*. This view clearly manifests the influence of the traditional eighteenth-century "pictures with classical ruins." Indeed, Cassas boldly filled his composition with the monument proper, allowing only a hint of the view that the particular site offered to the visitor. The monument's proportions are slightly exaggerated to provide an overpowering sense of grandeur. The site's picturesque possibilities are stressed by the elaborately drawn weeds that crown the structure's crumbling top, and the group of static figures in the foreground contribute further to the artist's intended theatrical effect.

Reference

Benezit, 2:578; Thieme-Becker, 6:125-26; A. Boppe, *Les peintres du Bosphore au 18e siècle* (Paris, 1911), 151-52; Tsigakou, *Rediscovery*, 194, pl. III; Navari, *Blackmer Collection*, 63.

11. VIEW OF THE AREOPAGUS 1846

Thomas Hartley Cromek (1809-1873)
Watercolor on paper
24.0 x 48.5 cm
Inscribed (lower right, in Greek): Thomas Cromek 1846
Inv. no. 24319

The Areopagus, or Hill of Mars (Ares), a rocky knoll opposite the Propylaea, was the most ancient tribunal of Greece. Before the classical period a select group of citizens formed the Council of Areopagus, which was invested with the highest legislative and judiciary powers in the Athenian state. After the fifth century B.C. the council's powers were drastically reduced, and it acted only as a court of law trying homicide cases. In legendary times if a god or a hero was accused of murder, he would appear before the Council of Areopagus. As related in Aeschylus' tragedy *Oresteia*, it was on the Areopagus that Orestes was put to trial for having murdered his mother. It was also there that in A.D. 51, St. Paul preached his sermon to the Athenians, revealing a new, "unknown" God.

Thomas Hartley Cromek was certainly aware of the site's literary and historical associations. In his approach to the scene he tried to convey something of its solemn, almost menacing, presence. The rock is placed diagonally against a flat landscape, framed by lines of mountains and a glimpse of sea to the far left. Its precipitous, broken surface is rendered in brown ochre, while a sober brown tint pervades the whole view. With a remarkable economy of means, Cromek created a composition that is dramatic and creative in nature. Characteristically he let his imagination run to the point of signing the watercolor in Greek.

The British landscape painter visited Greece twice: briefly in 1834 during an extensive tour of the Mediterranean, and again in 1846, when he spent two months in Athens. In the nineteenth century Greece was a favored destination for British artist-travelers, whose interest in depicting its sites had started in the previous century with the delineation of ancient buildings. Publications such as Stuart and Revett's *Antiquities of Athens* (1762-1816), sponsored by the Society of the Dilettanti, stemmed from the neo-classical interest in the revival of Greek architecture. Englishmen of all kinds, including architects, artists, classical scholars, topographers, and collectors, were in Greece in the early 1800s. "It is a passport to literary 'distinction' to be a member of the 'Athenian Club' and to have scratched one's name upon a fragment of the Parthenon," declared the *Quarterly Review* in 1814. Byron's death in Missolonghi (see cat. no. 57) and his contribution to the Greek cause proved an additional attraction to British visitors in Greece after the Liberation.

Reference
Benezit, 3:283; Thieme-Becker, 8:155; S. Redgrave, *A Dictionary of Artists of the English School* (London, 1970), 107; Tsigakou, *Rediscovery*, 71, 140, 144-45, 202.

12. VIEW OF ATHENS FROM THE ILISSUS 1833

Johann Michael Wittmer
(1802-1880)
Watercolor on paper
24.5 x 39.5 cm
Inv. no. 23991

This particular view of Athens was a favorite among nineteenth-century artists, for it allowed them to represent the city with most of its famous monuments, such as the Acropolis, the Temple of the Olympian Zeus, and Hadrian's Arch. The latter, built in honor of the emperor Hadrian in the second century A.D. and subsequently incorporated into the Turkish city wall, was used as one of the main city gates and was known as Kamaroporta (the Arched Gate). The Ilissus, formerly the principal river of Athens, was almost completely dried up by the 1830s. Although its orchard trees and shrines were no longer in sight, the location remained rich in classical associations to the educated visitor. It was the verdant banks of the Ilissus that had inspired Socrates' lyrical description at the beginning of Plato's *Phaedrus*. This part of Athens changed radically during the Othonian period, when it gradually became a popular residential area. The Turkish wall was demolished in 1834 to make room for the new Athens to expand freely.

At the time of Johann Michael Wittmer's journey to Greece, the new capital of the Hellenic kingdom supported a population of 3,000 people. Architecturally it presented the visitor with the sight of small and simple houses surrounded by heaps of ruins. King Otho's ambitious town-planning projects had not yet been put into action (see cat. no. 52). Nevertheless, the combination of humble modern buildings, charming Byzantine churches, and old ruins crowned with weeds next to the magnificent classical relics, all sparkling under the blue Attic sky, offered an unforgettable spectacle. After Otho's arrival, the attempt to transform Athens into a European capital became a challenge for foreign architects. Soon neo-classical mansions and houses sprang up which were to shape the physiognomy of the capital of the young Greek kingdom.

Wittmer, a German landscape painter, lived in Rome between 1828 and 1843, where he studied on a scholarship granted by King Ludwig I of Bavaria. Towards the end of 1833, he went to Greece as a member of the suite of Prince Maximilian of Bavaria, brother of King Otho, who just a few months previously had been offered the Greek throne. In this watercolor Wittmer rendered Athens exactly as foreign visitors considered it to be: one of the most picturesque towns in the Mediterranean. His composition unifies architectural elements from the city's ancient and modern history. White classical columns, red roofs, and church domes are seen through the slender colonnade of the Olympeion, as if viewed through a screen. A group of colorfully dressed Athenians in the foreground vivify this authentic representation of a visually arresting town bathed in a limpid atmosphere.

Reference
Benezit, 10:773; *Athen-München*, Bayerisches Nationalmuseum Bildführer 8 (Munich, 1980), 33; Tsigakou, *Rediscovery*, 68.

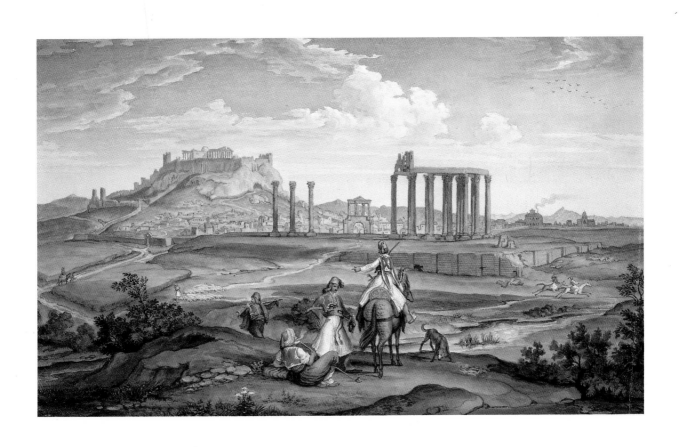

13. VIEW OF THE THESSEION FROM THE SOUTHEAST
Ca. 1838-39

Jean Nicolas Henri de Chacaton
(1813-after 1857)
Watercolor on paper
22.0 x 29.0 cm
Signed (lower right):
H. de Chacaton
Inv. no. 23970

Better known by its common name Thesseion, this classical temple, built in 449-444 B.C., was consecrated to Hephaestus and Athena. It stands on the hill of Agoraios Kolonos, where in ancient times the iron and metal workers of Athens were located. Therefore, it was only natural that the temple be dedicated to Hephaestus and Athena, patrons of the arts and crafts. Converted into a Christian church in the sixth century A.D., it did not undergo any further changes during the Turkish occupation. The Athenians dubbed it "St. George the Lazybones" (*O Akamatis*) because the Turks allowed them to hold services there only once a year. After the Liberation it became the most important church in Athens. The first ceremonial doxology to mark King Otho's official arrival in Athens took place there on December 1, 1834. Two months later the building was deconsecrated, and until 1874 it served as the Archeological Museum. Today it ranks as the best preserved classical temple in Greece.

This view shows the Thesseion's southern side, which in ancient times was the principal facade overlooking the Agora, or market. Part of its pediment was slightly damaged when, in order to transform it into a church, an apse was added. The houses depicted here as well as those in the surrounding area were demolished in the 1850s to make way for the excavations of the Agora, which in the twentieth century were undertaken by the American School of Classical Studies in Athens.

Chacaton created here a freshly spontaneous picture. While concerned with the depiction of the temple, he could not resist conveying the charm of the simple houses, people sitting on the doorsteps, and the brilliant light of a fine day.

Reference
Benezit, 2:634; Thieme-Becker, 6:326; Tsigakou, *Rediscovery*, 69, 126, pl. XX; *Athens 1839-1900: A Photographic Record* (exh. cat.; Athens, 1985), no. 10.

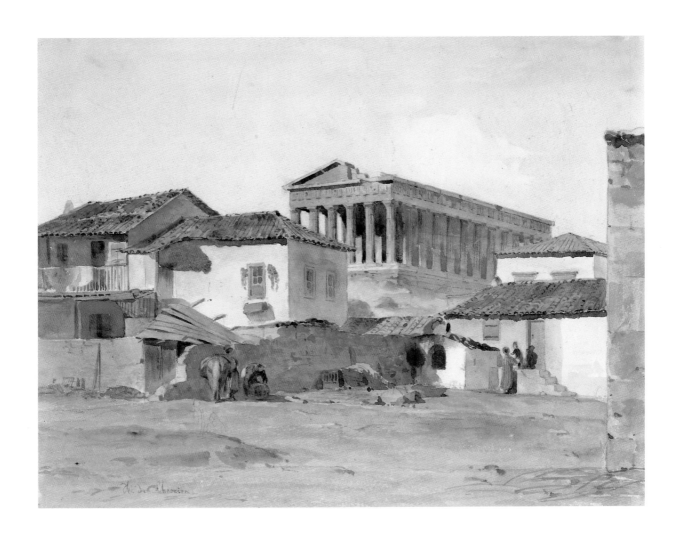

51

VIEW OF THE THESSEION FROM THE NORTHWEST Ca. 1860

Vincenzo Lanza
(1822-1902)
Watercolor on paper
24.6 x 36.0 cm
Inv. no. 22958

Seen from a position opposite the site represented in the previous watercolor (cat. no. 13), this view was drawn over twenty years later, when the open-air space in front of the Thesseion was used as a horse market. That explains the pitched tents that figure in the foreground. Unlike Chacaton's free composition, this carefully arranged picture furnishes a view with the splendid background of the Acropolis. The foreground is covered with *Athanata*, ever-lasting bushes that are so typical of the Greek landscape. Here, however, the artist treated them allegorically to underscore the ever-lasting presence of the classical spirit. In terms of color this painting is finely executed. The Thesseion is bathed in a golden light that vividly contrasts with the silver green of the bushes in the foreground and mid-distance to the left of the temple. It is an idealized Athenian view typical of Lanza's work.

The Italian landscape painter Vincenzo Lanza was established in Greece from 1850. A teacher at the School of Fine Arts and a popular society painter, he frequently executed commissions for the royal couple. His Greek scenes, which focused on Greek antiquities, were influenced by the romantic classicism of the European philhellenic tradition.

Reference

Lydakis, *Dictionary of Greek Painters*, 218; Tsigakou, *Rediscovery*, 201-202, pl. XXI.

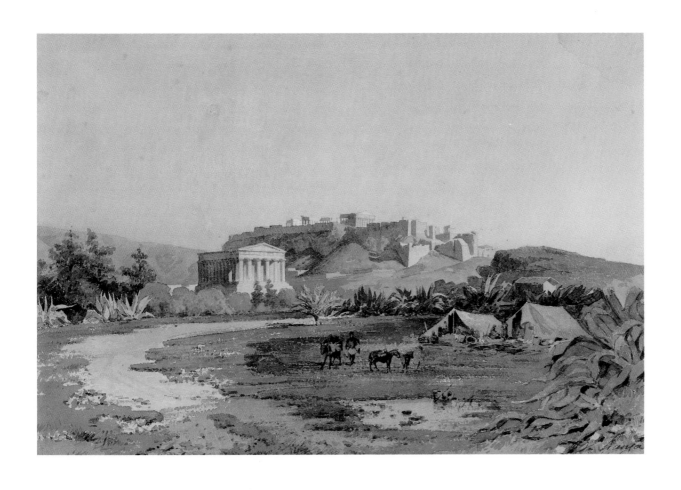

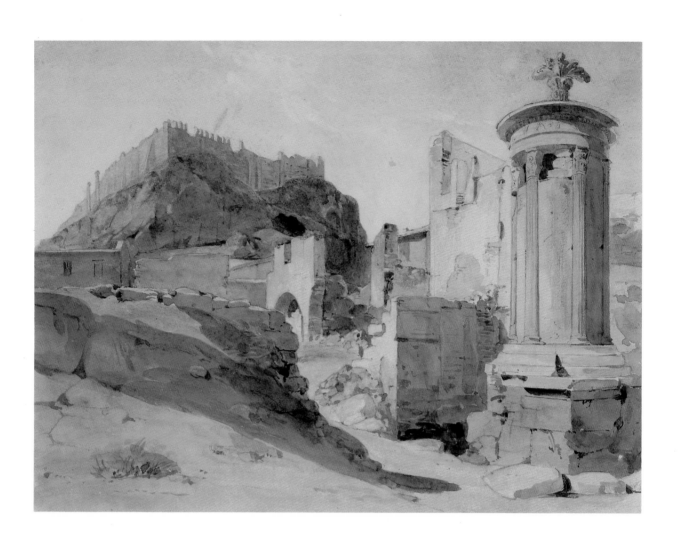

15. **VIEW OF THE CHORAGIC MONUMENT OF LYSICRATES 1838-39**

Jean Nicolas Henri de Chacaton (1813-after 1857) Watercolor on paper 19.5 x 26.5 cm Inv. no. 23971

The Monument of Lysicrates stands as one of the best choragic monuments extant. *Choregoi* (sponsors) was the name given to wealthy Athenian citizens who undertook the expense of producing and staging the plays in the drama competitions. The prizes given to the winning sponsors were tripods displayed in marble structures built in the form of a small temple. Lysicrates' choragic monument, a small, marble rotunda surrounded by Corinthian columns and resting on a square base, was constructed in 335-334 B.C. Since Byzantine times it was thought to be associated with either the orator Demosthenes or the philosopher Diogenes and was referred to as "the Lantern of Demosthenes" or "of Diogenes." This caused the area around it to be called *Fanari* (lantern, in Greek).

The "lantern" was bought in 1669 by the Capuchin monks, who enclosed it within their monastery wall and used it as a reading room. The monument, which was frequently painted by the artist-travelers who often resided in the Capuchin monastery, was immortalized by Lord Byron, who also lodged there during his winter sojourn in Athens in 1811. "I am living in the Capuchin convent," he wrote enthusiastically to his friends in London, "Hymettus before me, the Acropolis behind…the town to the left. There's a situation! There's your picturesque!" During the War of Independence the monastery was totally destroyed. The monument itself remained in a state of neglect for a long time after the Liberation because it was claimed by the French on the grounds that it had once been owned by French monks.

This watercolor constitutes an invaluable document for archeologists as well as for historians since it provides a faithful image of post-revolutionary Athens ruined by the war and littered with tumbledown houses and heaps of ruins. In pictorial terms the slender monument figures effectively against the imposing mass of the Acropolis. The overgrown, crumbling walls, exposed foundations, and stone staircases that lead nowhere form a perfect Romantic setting that alludes to the ravages of time.

Reference
Benezit, 2:634; Thieme-Becker, 6:326; Tsigakou, *Rediscovery*, 69, 126, 201, pl. XX; F.-M. Tsigakou, *Lord Byron in Greece* (exh. cat.; Athens, 1988), 23-24, 85-86.

16. VIEW OF THE CHORAGIC MONUMENT OF LYSICRATES AND THE RUINED QUARTER OF FANARI 1863

Vincenzo Lanza
(1822-1902)
Watercolor on paper
19.0 x 26.0 cm
Inscribed: Lanza 1863
Inv. no. 22932

Another depiction of the Choragic Monument of Lysicrates shows the area around the structure over twenty years after Chacaton's watercolor (cat. no. 15). The road has been cleared, and the monument is no longer squeezed between later buildings. A comparison of the two pictures brings to mind an observation made by the British architect William Cole, who visited Greece after the Liberation. "By the devastation consequent upon the struggle of the Greeks for liberty, all the rude buildings which had for centuries deformed and obscured the noble relics of ancient art were removed, and thus an opportunity was afforded of examining their proportions and appreciating their beauties."

This area of Athens was never properly developed. Despite a few modern intrusions, it has fortunately managed to retain its nineteenth-century character and today forms the oldest and most picturesque part of modern Athens.

Reference

Lydakis, *Dictionary of Greek Painters*, 218; Tsigakou, *Rediscovery*, 201-202, pl. XXI; S. Papadopoulos, *Liberated Greece and the Morea Scientific Expedition, The Peytier Album* (Athens, 1971).

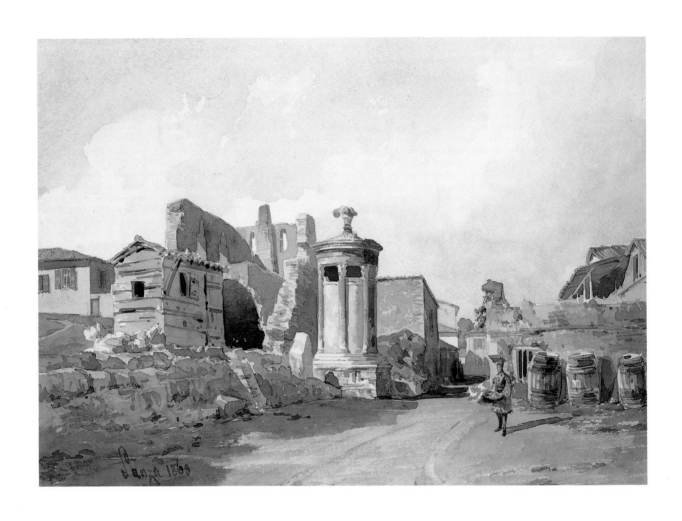

17. VIEW OF HADRIAN'S LIBRARY 1839

Jean Nicolas Henri de Chacaton
(1813-after 1857)
Watercolor on paper
22.5 x 35.5 cm
Inv. no. 23972

The sumptuous colonnade that occupies the right-hand side of the street depicted here forms the front of Hadrian's Library, an immense building erected in A.D. 132 adjacent to the Roman market. Nineteenth-century travelers referred to it as the "Stoa of Hadrian" or the "Gymnasium" among other names, since the structure was not definitely identified until 1885, when systematic excavations began.

To the right of the colonnade, seen squeezed between two columns, is the tiny Byzantine church of Ayii Asomati. Chacaton's depiction of it remains a unique record, for only four years after his visit, in 1843, the church was pulled down during a period of classical frenzy in Athens. Various other churches that were thought to obstruct adjacent classical buildings were demolished. The revival of religious subject matter in art, together with a new interest in Byzantine studies in the late 1840s, led to a re-evaluation of the surviving Byzantine monuments in Greece. The French scholar A.-N. Didron, in his *Manuel d'iconographie chretienne Grecque et latine* (published in 1845) urged King Ludwig of Bavaria to persuade his son, the king of Greece, to stop pulling down Byzantine edifices within the classical Greek sites.

The Turkish building facing the street in the mid-distance is the Djisdaraki Mosque, otherwise known as the Mosque of the Lower Fountain. It was erected in 1759 by the *voivode* (governor) Djisdaraki, who calcined one of the columns of the Temple of the Olympian Zeus in order to obtain lime for its construction. Chacaton's composition is enlivened by brightly dressed people who seem animated by a pleasant play of light and color. The artist thus created a faithful and unpretentious record of a gay Mediterranean scene.

Reference
Benezit, 2:634; Thieme-Becker, 6:326; Tsigakou, *Rediscovery*, 69, 126, 201, pl. XX.

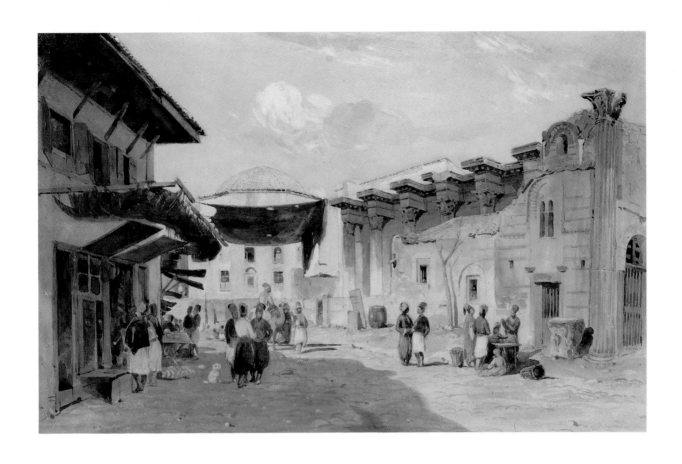

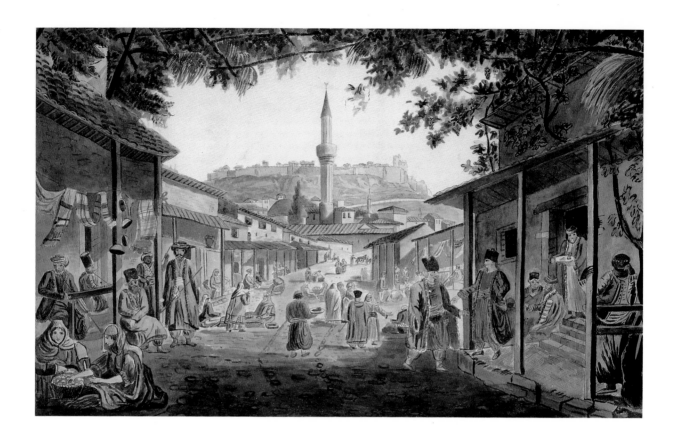

18. VIEW OF THE MARKETPLACE IN ATHENS 1801/1805-6

Edward Dodwell
(1767-1832)
Watercolor on paper
26.0 x 39.0 cm
Inv. no. 23059

Ever since ancient times the administrative and commercial center of the city of Athens was the Agora. During the Turkish period the marketplace, or the Bazaar, which covered the area around the Roman Agora and Hadrian's Palace, became the heart of the city. Full of life and color, its neighborhood marked by a wide range of classical, Byzantine, and Turkish monuments, the marketplace fascinated travelers and inspired some of their most vigorous pictures.

The British topographical draftsman, antiquarian, and collector Edward Dodwell ventured to Greece twice: in 1801/2 accompanied by Sir Willian Gell (see cat. no. 32), and in 1805, when he toured mainland Greece and the Ionian Islands in company with the Italian artist Simone Pomardi. Dodwell's folio of aquatints, published in 1821 with the title *Views in Greece*, includes an identical image entitled *Bazaar of Athens*, which is obviously based on this watercolor.

According to the artist's description in the text, on the right-hand side is seen a coffee shop frequented by important people, such as the *disdar* (the Turkish garrison commandant), who is depicted in a scarlet gown smoking his long pipe. The large building at the end of the street is the *Voivodalik*, the residence of the Turkish governor (*voivode*) of Athens, which was built beside Hadrian's Library. The tall minaret belongs to the Djisdaraki Mosque (see cat. no. 17); the Acropolis dominates the background. Various shops appear on both sides of the street, while all types of vendors crouch next to their baskets. This variety of races and classes led Dodwell to conclude that "Greeks, Turks and Albanians are seen mingled together and, while the variegated diversity of their costumes gratifies the eye of the beholder, the irreconcilable dissonance of their manners supplies ample material for reflective remark and philosophical contemplation."

The figures were drawn after sketches by Pomardi. Dodwell constructed his views simply— with the aid of a camera obscura—and often incorporated a diversity of elements. He produced a large quantity of Greek drawings and published several works on the country: *A Classical and Topographical Tour through Greece* (2 vols., London, 1819), *Views in Greece* (London, 1821), and *Views and Descriptions of Cyclopian or Pelasgic Remains in Greece and Italy* (London, 1834).

Reference
Benezit, 13:605; Thieme-Becker, 9:361; Tsigakou, *Rediscovery*, 26, 28, 85, 110, 142, 143, 157, 162, 178, 199, 200; Navari, *Blackmer Collection*, 107-108.

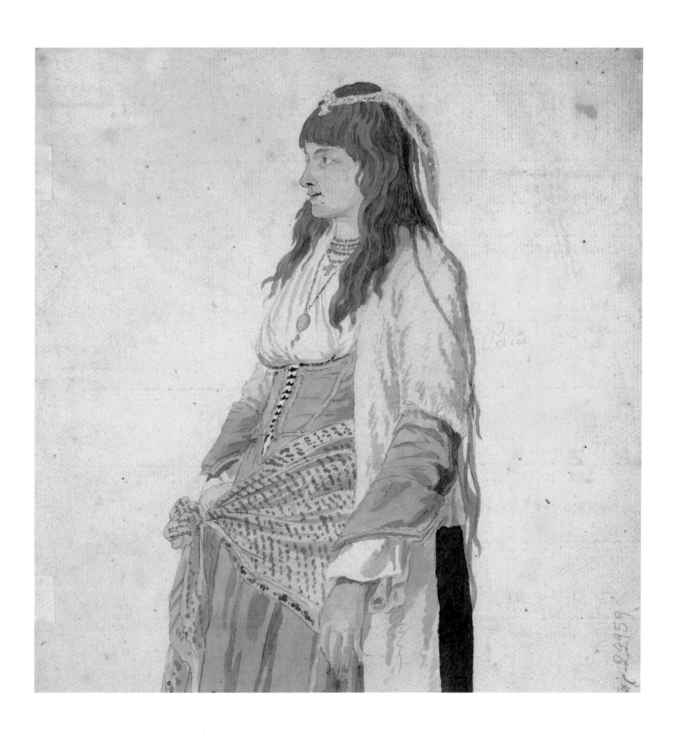

19. AN ATHENIAN MAID 1819

Louis Dupré
(1789-1837)
Pencil and wash
on paper
24.2 x 24.5 cm
Inscribed with notes on
costume accessories
Inv. no. 22959

The traditional costumes of Greek women seem to have been fashioned to make a visual impression or to symbolize ideas rather than to enhance the beauty of the body. The diversity that characterizes female costumes resulted not only from multiple regional variations but also from subtle social distinctions (i.e., the costume reveals the woman's status, such as old, young, married, unmarried, engaged, mother, or widow). Regional female costumes began to lose their distinctive character towards the end of the 1800s, due to the permanent invasion of western European fashion introduced by the foreign queens of Greece.

Nevertheless, it was a woman's duty to produce her own clothes as well as her household textiles. Nineteenth-century Greek women knew how to prepare fiber for spinning, and how to weave, sew, and embroider. The basic items in female costumes comprised a shirt, a dress or a typé of dresscoat, and an overcoat that was usually sleeveless. These were worn with various waistcoats or jackets. A typical accessory of peasant women was the apron. Footwear was usually of leather and wool. Women's costumes were accompanied by a profusion of silver, gold, and other ornaments, which adorned the wearer's body and head in elaborate combinations.

Depicted here is a girl dressed in the typical everyday costume of Attica: a simple white shirt with long sleeves, and over this a *kavadi*, a long dress open down the front. Around her waist and hips she wears a large printed kerchief (called a *tsevres*) tied at an angle. On her head is a small, flat cap bound with a muslin kerchief, which was the common headdress of Athenian women in the early nineteenth century. A cross and a pendant hang around her neck and on her chest. A woolen shawl covers her shoulders.

Charming illustrations of Greek ladies are included in Dupré's folio of colored lithographs entitled *Voyage à Athènes et Constantinople* (see cat. no. 9), particularly plates 16, 26, 29, 33, and 39. The most famous is plate 26, *An Athenian Girl*, who supposedly represents Miss Roque, a cousin of Theresa Makri, who was immortalized by Lord Byron in his poem "Maid of Athens." In fact, thanks to the Byronic tradition, Athenian women were given special attention by artist-travelers. Variations of "maids of Athens" were seen frequently in European exhibition rooms until the end of the nineteenth century.

Reference
Benezit, 4:44; Thieme-Becker, 10:177-78; A. Hatzimichali, *The Greek Folk Costume*, 2 vols. (Athens, 1977), 1:26-39; Tsigakou, *Lord Byron in Greece*, 23, 78-82, pls. 86, 88-90.

**A GREEK OF
HYDRA, A GREEK
OF IOANNINA
1819**

*Louis Dupré
(1789-1837)
Pencil on paper
37.0 x 39.5 cm
Inscribed (in French):
Greek from Hydra—
Greek from Yannina
Inv. no. 23197*

Greek traditional costumes for men were of sober color and simple decoration: white shirt and an undergarment of trousers or a kind of multipleated skirt known as a *foustanella*. In coastal areas and on the islands the typical male garment was the *vraka*, a sort of wide, baggy trousers. These basic garments were accompanied by several waistcoats and jackets worn one over the other in such a way that their embroidered parts would not obscure one another. A belt and/or a sash were worn around the waist. Sleeved overcoats or capes were donned in winter. Cloth leggings related to the length of the outergarment were usually secured below the knee with specially woven garters. Men's and women's footwear were alike, crudely made of pig leather by the villagers themselves. The basic headcover was the *fessi*, a plain or tasseled cap.

These two Greek men are studies for figures illustrated in Dupré's folio of lithographs (see cat. no. 19). On the left is *A Greek of Hydra* (plate 27) and the other, *A Greek of Yannina* (plate 10). Both sketches were made from life during Dupré's visit in 1819. The man from Hydra wears the typical islander's costume: a short vraka with a shirt and a cummerbund. The faint, pointed edge sketched behind the figure's back represents part of the anchor against which he leans in the lithograph. The other man's costume appears much heavier since the town of Ioannina (or Yannina) is situated in the mountain region of Epirus. His shirt is tucked into a long foustanella, which is worn with a long-sleeved waistcoat and a heavy shepherd's cap. He also wears a shaggy cloak with coarse woolen yarns on the inner side, which could be used as a blanket. Embroidered woolen leggings are shown below the kilt. Around his waist he wears a *selachi*, a thick belt made of heavy material sewn over leather, which served as a combination belt and pocket.

Both studies are inscribed with numerous notes as to the colors of the various garments. A comparison between these studies and plates 10 and 27 of Dupré's folio indicates that the final lithographs are faithful to the sketches both in terms of composition and coloring instructions.

Reference
Benezit, 4:44; Thieme-Becker, 10:177-78; Tsigakou, *Rediscovery*, 99, 188, 191, 195; Navari, *Blackmer Collection*, 113; I. Papantoniou, *Greek Costumes* (Nafplion, 1981), nos. 9, 10, 17.

Grec d'Hydra.

Grec de Janina

65

21. A GREEK
 1842

Joseph Scherer
(1814-1891)
Pencil on paper
40.0 x 26.5 cm
Inscribed (lower right,
in German): Athens in
December 1840
Inv. no. 24075

This drawing illustrates the type of elaborately embroidered costume with long foustanella that was originally worn as the military uniform of Greek chieftains and prevailed in most urban Greek centers. Towards the mid-nineteenth century King Otho established it as the formal court dress. The rich foustanella depicted here demonstrates that in order to fashion a good one, more than forty yards of cloth were needed.

The man's upper garment consists of a *yileki*, a sleeveless waistcoat used for daily wear, and a *fermeli*, a long coat worn on festive occasions. Its long sleeves could be unbuttoned so they fell freely on the back. A heavy cloak protects his shoulders. His legs are covered with long leggings, and his footwear consists of *voulia*, pigskin shoes fitted with leather straps. On his head sits a large, tasseled cap, or *fessi*, wrapped with a kerchief in a turbanlike fashion. He holds the indispensable male accessory of the time, the *tsimbouki*, a long, earthenware tobacco pipe. Joseph Scherer's depiction of these various articles indicates an almost scientific interest in the subject. His acute observation extends to such details as the numerous buttons along the sleeves of the fermeli and the carved handle of the knife tucked through the man's sash.

A large collection of costume drawings by Scherer in the Benaki Museum testifies to his remarkable draftsmanship. The artist's sketches of people in local dress verify his delight in observation, but these figures were not treated merely as costume studies. For example, this handsome man has assumed an elegant pose, as if proud to be the object of the artist's attention.

Scherer was in Greece from 1842 to 1844 as part of the team of artists who were sent by King Ludwig of Bavaria to decorate his son's royal palace. The German painter's Greek works are mainly genre scenes.

Reference
Benezit, 9:364; Thieme-Becker, 30:35; H. Holland, "Joseph Scherer," in *Die Christliche Kunst* 11 (1914-15): 33-34; Papantoniou, *Greek Costumes*, 47; Tsigakou, *Rediscovery*, 68, 69-70, 147, 202.

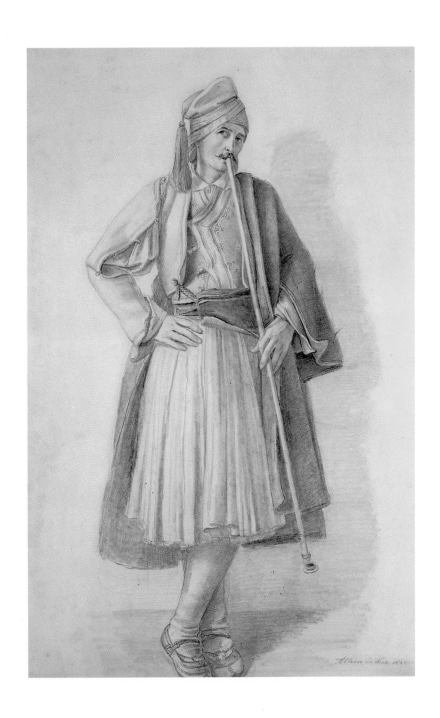

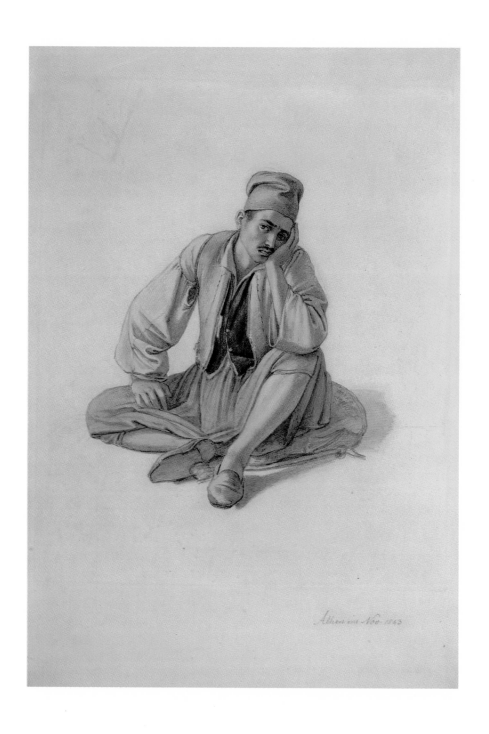

22. A GREEK
1843

Joseph Scherer
(1814-1891)
Pencil on paper
31.5 x 26.5 cm
Inscribed (lower right,
in German): Athens,
Nov. 1843
Inv. no. 24011

The young man depicted here wears an islander's costume in its simplest form: a waistcoat over a shirt, a *vraka* (short, baggy trousers), and a large fessi on his head. A closer look at the drawing reveals that the man's waistcoat is ragged, his shirt torn, and his slippers patched. This leads to the interpretation that this young man was perhaps one of the many refugees who fled to Athens due to the devastation that most Greek islands suffered after the War of Independence. The sitter's unfortunate condition is not only indicated by his tattered clothes but is also evident by the tortured, sorrowful expression on his face. With sensitivity and affection Scherer has drawn the portrait of a war victim reduced to homelessness.

Reference
Benezit, 9:364; Thieme-Becker, 30:35; Holland, "Joseph Scherer," 33-34; Papantoniou, *Greek Costumes*, 47; Tsigakou, *Rediscovery*, 68, 69-70, 147, 202.

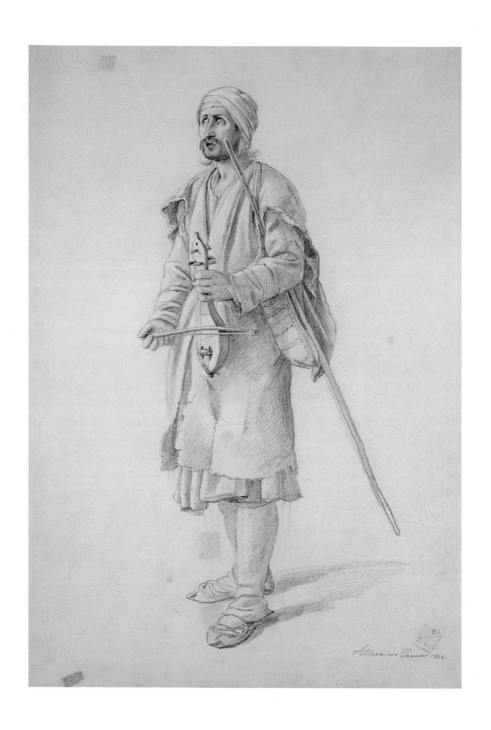

23. A BLIND STREET MUSICIAN 1844

Joseph Scherer
(1814-1891)
Pencil on paper
41.0 x 28.0 cm
Inscribed (lower right, in German): Athens in January 1844
Inv. no. 24043

Blind street musicians, such as this old man who wears the remnants of a foustanella under his ragged cape, were often seen in the streets of Athens. His legs are wrapped in heavy woolen leggings, and instead of shoes he wears crudely made sandals. An old kerchief covers his head. He holds a bowed, violin-type instrument known as a lyre and carries a long walking stick under his left arm. Travelers frequently drew these unfortunate figures, as did Theodore Leblanc in his folio of lithographs entitled *Croquis d'après nature*, published in 1833. Romantic artists liked to invest these people, who were usually the victims of the Greek War of Independence, with classical connotations. A blind street musician was often seen as a contemporary version of Homer, the most famous blind bard of ancient Greece. This is why travelers referred to them as "bards" (see Leblanc, plate 19).

Scherer was probably aware of such imagery, but he did not approach his theme purely in terms of pictorial subject matter. Thanks to his sensitivity and perceptiveness, he created a picture of a dignified yet helpless figure who bears a stoic expression on his face. Even though Scherer might appear to allude to Greece's heroic past, he nevertheless incites the viewer's compassion.

Reference
Benezit, 9:364; Thieme-Becker, 30:35; Holland, "Joseph Scherer," 33-34; Papantoniou, *Greek Costumes*, 47; Tsigakou, *Rediscovery*, 68, 69-70, 147, 202.

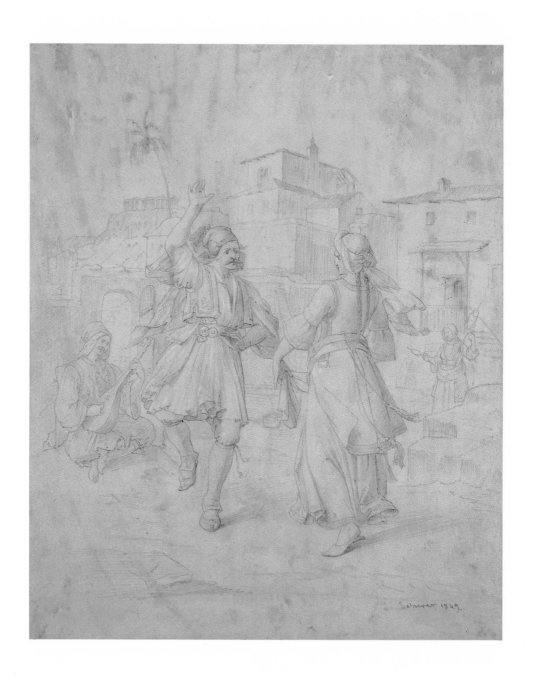

24. A GREEK FOLK DANCE 1849

Joseph Scherer
(1814-1891)
Pencil and white chalk
on paper
27.5 x 22.5 cm
Inscribed (lower right):
Scherer 1849
Inv. no. 24036

From the mythological period to the present time, Greeks have recorded their joys and tragedies in song and dance. For the Greeks dancing is a natural tradition that accompanies feasts, anniversaries, and other occasions of family rejoicing. The most common dance is the circular group dance in which a man and a woman detach themselves to perform a vivid *pas de deux* with intricate swirls and jumps. The scene represented here also matches the description by a contemporary British traveler. "I have seen circles of white-kilted men and women joining in the popular dance to the music of drum and fife….The dancers who form the ring are generally linked together by holding on to bright-coloured handkerchiefs…. In the middle of the ring,…sometimes a man and a woman execute the most marvellous steps until exhausted, when their place is taken by fresh dancers."

These figures perform their dance to the sound of a drum played by the man on the left. Scherer has caught the agility of their steps perfectly. The background, which looks like a stage design comprised of picturesque Greek images—the Acropolis, Athenian houses, a woman spinning— further underscores the idea of a "performance" initiated by the dancers.

Reference
Benezit, 9:364; Thieme-Becker, 30:35; Holland, "Joseph Scherer," 33-34; Tsigakou, *Rediscovery*, 68, 69-70, 147, 202.

25. A GREEK ISLANDER
1776

Jean-Baptiste Hilair
(1753-1822)
Watercolor on paper
13.5 x 9.0 cm
Inscribed (lower left):
J. B. Hilair 1776
Inv. no. 24022

A Greek from the islands of the eastern Aegean Sea is represented here festively dressed in a short vraka and a set of elaborately embroidered waistcoats. Fine weapons are thrust through his cummerbund, and his head is covered with a cap wrapped with a kerchief in a turbanlike fashion. The indispensable tsimbouki completes his outfit. He stands on the shore and turns his back on the imaginary naval battle that is presumably taking place in the background, as indicated by the clouds of smoke that rise from the three tiny ships slightly visible on the right-hand side.

The French artist Jean-Baptiste Hilair made a large series of drawings on the spot when he spent a year in Greece as a member of the suite of the French count Marie-Gabriel-August-Florent de Choiseul-Gouffier, who toured the Greek mainland and islands and the coast of Asia Minor in 1776. Between 1784 and 1792, Choiseul-Gouffier served as the French ambassador to Constantinople. From there he conducted archeological and topographical researches in the Levant, which resulted in a monumental publication entitled *Voyage Pittoresque de la Grèce* (2 vols., Paris, 1782-1822). Most of the plates are based on drawings by Hilair, who is considered one of the eighteenth-century artists who "penetrated the life of the Levant." Here Hilair drew his subject with fine, firm lines and delicately transparent tints that highlight the details of the intricate costume accessories.

Reference
Benezit, 5:539; Thieme-Becker, 17:66-67; P. Huisman, *French Watercolours of the 18th century* (London, 1969), 104, 130; Tsigakou, *Rediscovery*, 128, 201, pl. XVII.

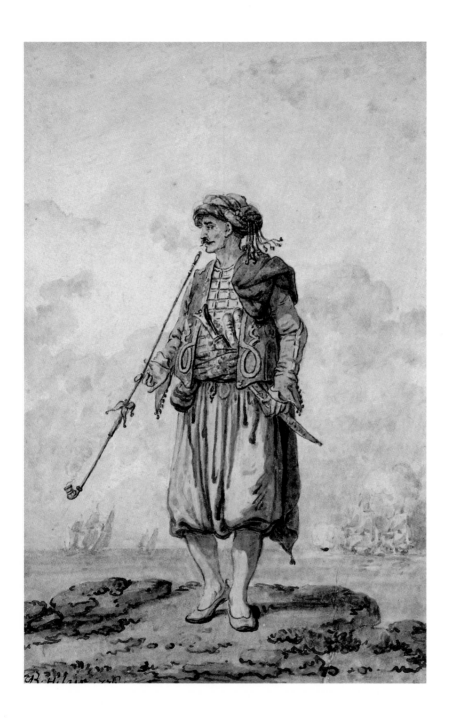

26. INTERIOR OF A HOUSE ON SIFNOS 1776

Jean-Baptiste Hilair
(1753-1822)
Watercolor on paper
6.5 x 9.5 cm
Inv. no. 24021

This view may be identified with the plate entitled *Women of the Island of Sifnos* after Hilair's drawing, which is included in volume 1, page 17, of Choiseul-Gouffier's *Voyage Pittoresque de la Grèce* (see cat. no. 25). According to the text, that plate represents a scene in the interior of a house on the Greek island of Sifnos. The image's basic elements, like those evident here, were often observed by visitors to a Greek peasant's house: a small room is partly filled by a large bed, and crowded with pets, children, and women at work. A Greek peasant woman's life was not an easy one. She fetched water, prepared food, watched over the children, and made the textiles and clothing items for her household.

Certainly Hilair had the opportunity to witness various aspects of Greek life during his extensive tour of the country, but his interest was mainly pictorial. Indeed, the majority of the Greek genre scenes that illustrate Choiseul-Gouffier's publication depict familiar and pleasant happenings. In picturesque households or courtyards elegantly dressed women carry water jugs or work at the spinning wheel surrounded by playful children. The same visual vocabulary has been used here to create an attractive scene drawn with the precision and charm of an eighteenth-century vignette. Although the documentary value of the scene cannot be entirely trusted, the artist attained perhaps a deeper sincerity through his talent for playing with the subtle washes of watercolor.

Reference
Benezit, 5:539; Thieme-Becker, 17:66-67; Huisman, *French Watercolours of the 18th century*, 104, 130; Tsigakou, *Rediscovery*, 128, 201, pl. XVII.

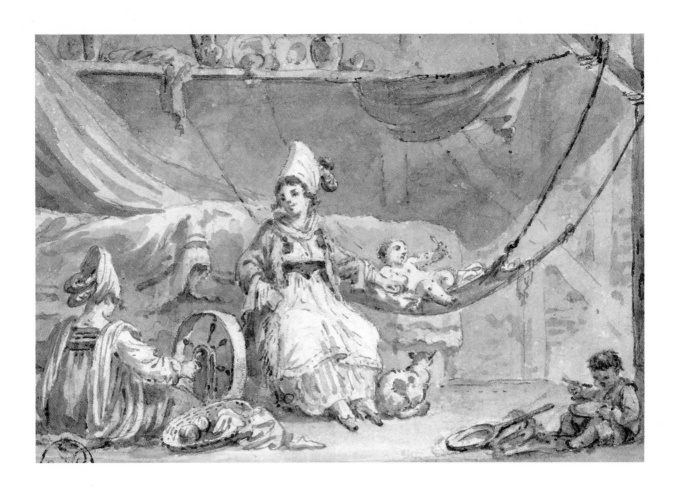

27. A GREEK EASTER CELEBRATION
Mid-19th century

Clotilde de Angelis
(act. mid-19th century)
Watercolor on paper
29.5 x 44.0 cm
Inscribed (lower left,
in French): C. Deangelis,
after nature
Inv. no. 23049

As one of the most popular religious festivals for Orthodox Greeks, Easter is a time of great rejoicing. Easter Sunday is an open-air festival celebrated with lamb roasted on the spit, dancing, and exultation. Its elaborate religious ceremonies are reinforced by popular rites that are also of considerable folkloristic interest.

The subject of this picture is Easter Sunday in a Greek village. With great concern for balance, the artist Clotilde de Angelis managed to integrate a large group of figures into a rich landscape. The composition, which features a tree set off in repoussé to the left, presents a group of people preoccupied with the roasting of a lamb. This principal scene is framed by another tree to the right whose branches direct the eye towards the background, which is dominated by a church surrounded by a vivid crowd of faithful peasants. Many of the more than fifty colorfully dressed figures are clearly depicted, making the drawing a visual panorama of traditional Greek costumes. The various cultures that have dominated Greece, in particular the Byzantine, Italian, and Turkish, have influenced the clothing worn by its inhabitants. This explains the surprising diversity that characterizes traditional Greek costumes. In fact, in every region, town, or village two or three versions of the same local costume may be found. In her depiction of such costumes, de Angelis achieved a remarkable degree of authenticity, and the specific features of the celebration were rendered with scholarly accuracy. Through the minute execution and successful realization of textures and forms, the artist managed to convey the joyous atmosphere of the occasion.

The scene must have been set in Corfu, judging from the scenery and the figures' costumes, most of which are either from the Ionian Islands or the western coast of Greece. Easily accessible from the Italian coast, the island of Corfu was highly popular with foreign artists (see cat. no. 42). Thus, it is not unlikely that the French artist de Angelis, who was a resident of Naples, actually witnessed the scene, as indicated by the inscription on the drawing.

Reference
Benezit, 1:193.

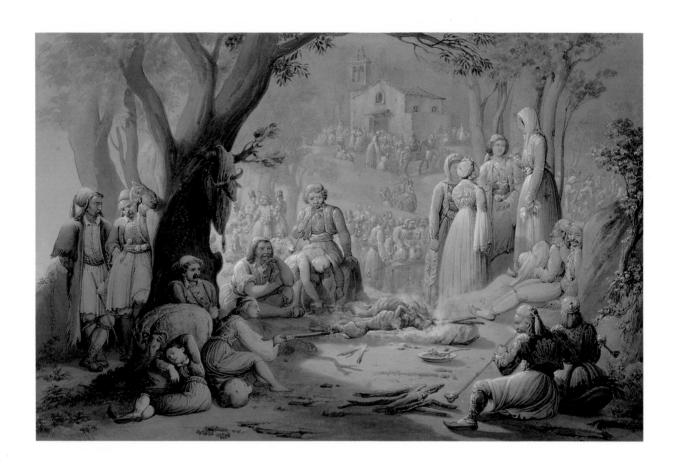

28. A GREEK MOUNTAINEER 1861

Carl Haag (1820-1915)
Gouache on paper
35.0 x 25.0 cm
Inscribed (lower right):
Carl Haag 1861
Inv. no. 23983

During the years of Turkish occupation, Greek peasants who were dispossessed of their property often retreated to impregnable mountain regions from where they engaged in resistance against the Turks. These mountaineers, who both fascinated and frightened European travelers, were romanticized by artists and poets such as Lord Byron.

And as the clouds break...
disclose the dwelling of the mountaineer

. .

To the wolf and the vulture he leaves his wild flock
And descends to the plain like the stream from the rock.

CHILDE HAROLD'S PILGRIMAGE

The man depicted here clearly represents the type of mountaineer described by Byron. To emphasize his costume and his swift movement, he appears in full gear, the sleeves of his jacket falling freely to the back as if to underline the speed of his gesture. Pistols and knives are tucked in his belt. His right hand rests on his musket; his left hand proudly touches the tip of his sword. The rich textures achieved by warm tones of body color are typical of the artist's work.

For a long period the German landscape painter Carl Haag was established in England, where he became a member of the Society of Painters in Watercolours. After his travels to North Africa and Greece (1858-61), Haag specialized in Eastern subjects. Here he chose to place the figure amidst a grand mountain scene, complete with a ruined temple. This sacred structure could be identified with the Temple of Apollo Epicurius in Arcadia in the central Peloponnese, which was celebrated both for its architectural proportions and for its location in a spectacularly grand area. Haag's selection was not accidental. The specific site and the temple were used allegorically to enhance the dignity of the figure, whose nobility and heroism are worthy of the principles of his legendary ancestors.

Reference
Benezit, 5:332; Thieme-Becker, 15:382-83; M. Hardie, *Watercolour Painting in Britain*, 3 vols. (London, 1968), 3:67; Tsigakou, *Rediscovery*, 127, 201.

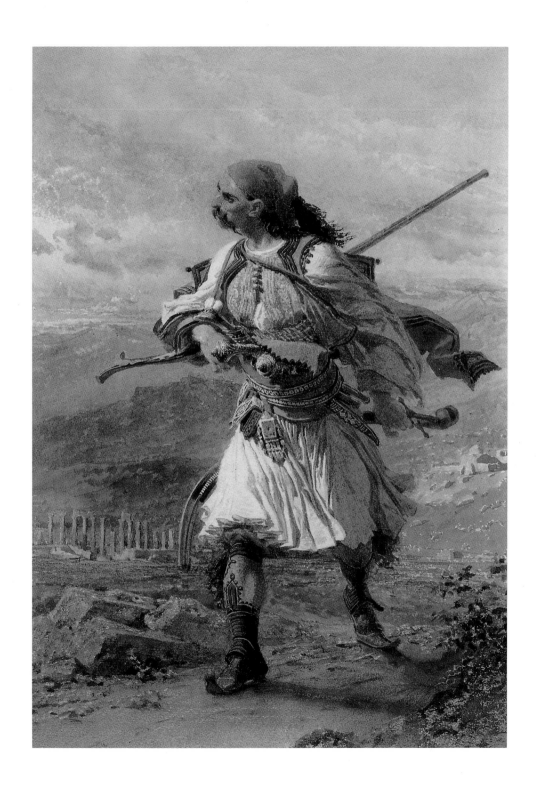

29. **A GREEK**
GIRL SPINNING
1861

Carl Haag (1820-1915)
Gouache on paper
35.0 x 25.0 cm
Inscribed (lower right):
Carl Haag 1861
Inv. no. 23982

Carl Haag produced this gouache as a pendant to the previous picture (cat. no. 28). The same Arcadian landcape serves as the setting, although here an "ever-lasting" bush and a prickly pear-tree, both typical plants of the mountainous Greek countryside, figure prominently in the foreground. The woman wears a white overdress decorated with polychrome motifs on the hem and a fully embroidered *sigouni*, a shorter, sleeveless dark coat. A wide kerchief is wrapped around her hips, and her head is covered with a gold embroidered scarf.

A woman spinning on a distaff, a common sight in rural areas of Greece in the nineteenth century, became a popular theme among artist-travelers. Like other painters, Haag made use of two pictorial aspects—the woman and the landscape—although he chose to explore their suggestive possibilities further. The woman's graceful pose, which recalls that of a classical nymph, and the Arcadian landscape successfully harmonize to suggest an idyllic pastoral Greek scene.

Reference
Benezit, 5:332; Thieme-Becker, 15:382-83; Hardie, *Watercolour Painting in Britain*, 3:67; Tsigakou, *Rediscovery*, 127, 201.

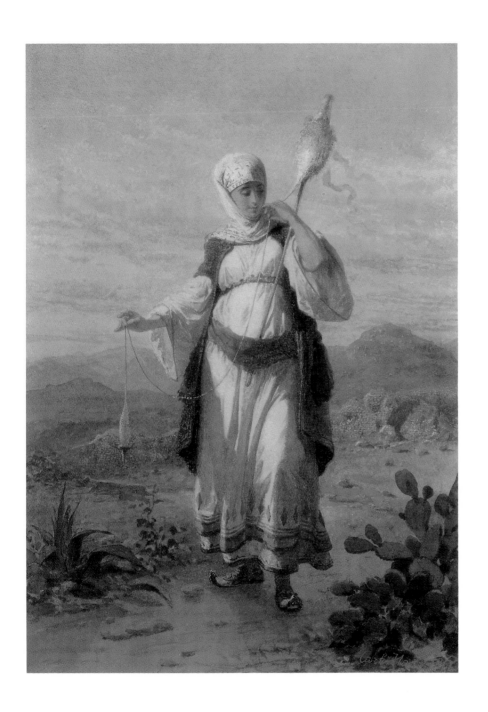

30. A GREEK COUPLE
 Ca. 1860

John Linton
(act. mid-19th century)
Oil on canvas
22.0 x 30.0 cm
Inscribed (lower right):
John Linton
Inv. no. 9006

This painting shows a young Greek couple sitting by the remains of an ancient sarcophagus. He plays the flute while she spins. In the background of the pastoral setting rises a white hill crowned by a classical temple, which presumably represents the Acropolis. If the figures in this stereotyped, classical "domestic" image had been dressed in draperies from antiquity, the picture might seem to illustrate a scene from Theocritus' *Idylls*. The various features of the composition—the figures, the Acropolis, the ruins—were treated as decorative elements in an aesthetic schema that is dominated by a pleasant simplicity and a deep feeling for color, which compensate for the naivete of the work.

A fine specimen of the Victorian fantasy of rural Greek life, this scene presented contemporary spectators with the opportunity to escape into a romanticized land of classical perfection and innocent people. It is not known whether John Linton visited Greece, but he seems to have been inspired by the Victorian taste for continental, picturesque sites that were easily accessible by tourists.

Reference
Tsigakou, *Rediscovery*, 69.

31. SCENE IN A GREEK INTERIOR Ca. 1850

George Cattemole
(1800-1868)
Watercolor on paper
21.5 x 29.5 cm
Inv. no. 22949

In this composition a woman sits on a low sofa and plays the lute in a loggia overlooking the sea. Two men in festive Greek costumes seem totally absorbed by the music as they sit on either side of her, smoking long pipes. The same applies to the three men who stand in the middle ground in somewhat frozen postures, as though they are transfixed by the sound of the music. This work stands out as a fine example of George Cattemole's facility in compositional arrangements and rapid handling of interior scenes. Rather than delineate specific architectural details, forms are loosely defined to evoke the serenity and refinement of the room.

Cattemole, a British watercolorist and a successful book illustrator and history painter, never traveled to Greece. Such "Greek" scenes reveal his primary preoccupation with images in which figures are represented in historical settings, a genre that made him one of the most popular Victorian artists of his day.

Reference
Benezit, 2:597; Thieme-Becker, 6:193-94; Hardie, *Watercolour Painting in Britain*, 3:88-92.

32. VIEW OF CAPE SOUNION 1801/2-1806

Sir William Gell
(1774-1836)
Watercolor on paper
19.0 x 34.0 cm
Inv. no. 22945

Travelers sailing to Greece invariably awaited the sight of the sparkling columns of Poseidon's temple on Cape Sounion, the southern most point of Attica. The Temple of Poseidon at Sounion, then known as the Temple of Minerva Sounias, was built in 444-440 B.C. Superbly situated on the summit of a promontory that plunges sharply into the sea, the temple was a favorite subject for artists and poets alike. Upon visiting the site in 1810, Lord Byron gave the best interpretation of how the romance of a place imposed on its actual physical appearance. "Ask the traveller," he wrote, "what strikes him as most poetical—the COLUMNS of Cape Colonna or the Cape itself?...There are a thousand rocks and caves far more picturesque....But it is the art, the columns, the temple,...which gives it its antique and modern poetry."

The evocation of the romantic possibilities of a locality was not a genre in which Gell excelled. A famous British classical topographer and a draftsman, Sir William Gell (nicknamed "Classical Gell" by Byron) toured Greece in 1801/2 accompanied by Edward Dodwell (see cat. no. 18) and returned again in 1806. His publication *The Geography and Antiquities of Ithaca* (London, 1807) was the first serious study of the topography of that area for its Homeric associations. Gell brought back from Greece a large series of topographical drawings, the majority of which (eight hundred) were bequeathed to the British Museum in London. He published the following additional works on Greece: *The Itinerary of Greece* (London, 1810), *The Itinerary of the Morea* (London, 1817), and *Narrative of a Journey in the Morea* (London, 1817-19). Like most of his Greek drawings, Gell's *View of Cape Sounion* is a simply constructed composition that exhibits some uncertainty as to the handling of masses. Nevertheless, he tried to convey something of the poetry of the site through his treatment of color.

Reference
Benezit, 4:662; Thieme-Becker, 13:366; Tsigakou, *Rediscovery*, 26, 30, 183, 193, pl. XI; Navari, *Blackmer Collection*, 142-44.

DISTANT VIEW OF SALAMIS 1838

William James Muller
(1812-1845)
Watercolor on paper
35.5 x 55.0 cm
Inv. no. 23318

In the nineteenth century the island of Salamis was largely in an uninhabited and uncultivated condition. It was, however, of historial interest to foreign travelers. Situated in the Gulf of Eleusis and opposite Piraeus, the island's waters had been the site of the famous naval victory of the Athenians over the Persians in 480 B.C.

This view is seen from Piraeus, which until the mid-1800s was in an almost deserted state. It was a suitable spot for the Romantic artist who wished to capture the island's elegant line of mountains and to contemplate a glorious vista, as did William James Muller. The British landscape painter paid a brief visit to Greece in September-October 1838. A true Romantic, Muller took little interest in the sites themselves and was vague about the niceties of the local atmosphere. "The remains of ancient buildings or temples . . . do not fit the artist's folio," he declared. To him, the landscape painter was "one who would delight in Nature, in her…moods and beauties." For this view of Salamis, Muller does not seem to have intended to make a topographically faithful record. Instead, he gathered and composed from all that surrounded him. This authentic Romantic view is a typical product of his noble design, fluent in brushwork and mellow in color. Both the features and the feeling of the landscape have been rendered to suggest a personal dialogue.

Reference
Benezit, 7:600; Hardie, *Watercolour Painting in Britain*, 3:55-63; Tsigakou, *Rediscovery*, 70-71, 178, 184, 204.

34. VIEW OF THE
TEMPLE OF APHAIA
IN AEGINA
1849

Edward Lear
(1812-1888)
Watercolor on paper
25.5 x 35.5 cm
Inscribed: E. L. Aegina
Inv. no. 24060

The island of Aegina, located only a few miles from Piraeus, was frequently visited by foreign artist-travelers who wished to admire and depict the Temple of Aphaia. Built towards the end of the fifth century B.C., this Doric temple was "excavated" in 1811 by a group of European architects, painters, and antiquarians who, upon finishing their archeological endeavors, took great care to secure the export of their priceless discoveries. Today, the sculptures from the Temple of Aphaia may be seen in the Staatliche Antikensammlungen und Glyptothek in Munich.

Greek subjects form a large part of the topographical output of Edward Lear, whose visits to Greece extended from 1848 to 1864. Lear's Greek works have a particular importance not only for their intrinsic qualities but also for their use as documentary evidence. He spent almost five years in the country traveling extensively and drawing places that had never been depicted. His visual records of Greece are supplemented by his publications *Journals of a Landscape Painter in Albania, etc.* (London, 1851) and *Views of the Seven Ionian Islands* (London, 1863), as well as by a large body of letters and diaries.

Lear journeyed to Aegina during his first Greek tour of 1848-49. Two more drawings of the same subject in the Benaki Museum (inv. nos. 24792-93) are dated "April 5 1849" and are inscribed with the following notes regarding the coloring instructions: "Flutings perly gray" and elsewhere, "all the stone is light and comes fearful off a dark purple sky." The latter is exactly the impression transmitted by this drawing, which represents a white screen of ancient columns sparkling against a blue sky. The composition is summary in treatment and testifies to Lear's vigorous shorthand style with pen and ink.

Reference
F.-M. Tsigakou, "Edward Lear in Greece", Ph.d. diss., University College, London, 1977; F.-M. Tsigakou, *The Travels of Edward Lear* (exh. cat.; London, 1983), 7-18; V. Noakes, *Edward Lear 1812-1888* (exh. cat.; London, 1985), 106-108.

35. VIEW OF THE ISLAND OF POROS 1835

Wilhelm von Weiler
(act. 1830s-1840s)
Watercolor on paper
34.0 x 52.0 cm
Inscribed: Kloster
Zoodochas Pigi auf
Kalamaki bei Poros
August 1835 v. Weiler
Inv. no. 24007

Situated at the edge of the Saronic Gulf and clinging to the east coast of the Peloponnesus, the island of Poros is more like a peninsula. A verdant island with pine forests reaching down to the water's edge and a harbor lined with brightly painted boats, it was a spot that suited both the traveler's demands and the artist's sketchbook, although drawings of Poros are uncommon. Wilhelm von Weiler's view was taken from the Monastery of Zoodochos Pege, an eighteenth-century edifice perched on a pine-fringed height amidst an idyllic setting near a spring, which is shown on the right. This vantage point offered the artist a vignettelike view of the Peloponnese coast, seen across a narrow strip of water through a frame of foliage. Also, from this site a well-hidden path led the classically minded visitor to the ruins of the Temple of Poseidon, famed as the location where the renowned orator Demosthenes sought refuge and poisoned himself in 322 B.C.

Greece's classical past did not preoccupy Weiler, a German military engineer who traveled the country in 1833 as part of the team of architects and engineers accompanying King Otho to his new "home country" (see cat. no. 52). Weiler spent three years in Athens, where he became involved in implementing a new plan for the city and constructing public buildings. Between 1837 and 1842, he was on the island of Syros supervising the town planning of Hermoupolis. He presumably left Greece in 1843, after nationalistic uprisings forced foreign civil servants to resign.

Reference
I. Travlos and A. Kokkou, *Hermoupolis* (Athens, 1980), 75-76.

Kloster Zvedeghos Pigi auf Salamis bei Piräus.
August 1835.

36. VIEW OF ANCIENT CORINTH 1849

Edward Lear
(1812-1888)
Watercolor on paper
29.0 x 51.0 cm
Inscribed: Corinth April 1 (106) 8 A.M. columns all very brown & gold smoke-coloured patches- holes like gruyere cheese
Inv. no. 24063

Corinth has been called the Gibraltar of ancient Greece, for it controlled the only road from central Greece to the Peloponnesus and its canal linked two seas. Owing to its prosperity and the strategic importance of its fortress, the Acrocorinth, the city was repeatedly attacked and plundered. After the Liberation, Corinth began to recover some of its past vitality, only to be devastated by a terrible earthquake in 1858. The most outstanding ancient monment that survived *in situ* in the nineteenth century was the Temple of Apollo. Built in the sixth century B.C. in the Doric style, the temple still overlooks the ancient marketplace and the gulf.

Lear visited Corinth during his tour of the Peloponnesus in 1849. This watercolor is the first of a set of views drawn on April 1, as the inscription "8 A.M." confirms. The artist was in the habit of writing down the exact time he made each drawing, which enabled him to record different light effects at various times of the day. In this simple composition free from artificial embellishments, the ancient temple is placed against the rock of the Acrocorinth, whose summit is surmounted by a medieval castle. The drawing testifies to the fact that Lear's tours of Greece were not prompted merely by a search for motifs: he had a genuine interest in the country's landscape and history.

In this view of Corinth, the various features of the landscape were carefully selected and organized to accentuate the history of the site. From the ancient temple the eye is led to the medieval fortress, both symbols of the city in different historical periods. The use of color is equally economical, yet effective. A quiet blue tone pervades the scene, whereas the warm brown washes over the columns allow the architectural elements to maintain their importance in relation to the landscape. A careful reading of the notes verifies that Lear accurately followed his own coloring instructions. Moreover, the notes testify to Lear's other capacity as a poet of nonsense, which made him a popular personality in the Victorian era. Penciled next to the columns appears "holes like gruyere cheese." Obviously the artist's genuine sense of humor did not obstruct his Romantic response to the site.

Reference
Tsigakou, "Lear in Greece"; Tsigakou, *Travels of Lear*, 7-18; Noakes, *Edward Lear*, 106-108.

Corinth
April 1 A.E.S.
1849

97

**37. VIEW OF
THE TEMPLE OF
APOLLO IN
CORINTH
Ca. 1820**

*William Purser
(1790-after 1834)
Sepia and watercolor
on paper
16.5 x 22.0 cm
Inv. no. 23110*

This view is identical to the plate (on page 350) after William Purser entitled *Ruins of an Ancient Temple at Corinth*, published in *Greece Pictorial, Descriptive, and Historical* (London, 1839). With a text by the classical scholar Christopher Wordsworth, that volume ranked among the most popular books of its kind. Extensive foreign travel was a habit the Victorians had inherited from the Grand Tourists, the leisured and learned aristocratic travelers of the eighteenth century. Consequently, during the Victorian period illustrated travel books were in great demand. Many of those produced were written by scholars, diplomats, or military officers and were illustrated by artists who were known chiefly as draftsmen of well-known sites on the Continent. The images in these books were addressed not to viewers in search of scientific information but to those who sought visual excitement—scenes of sunny shores, grandiose mountains, classical temples, ancient rivers, idyllic woods—that is, the whole range of the picturesque repertoire.

This is exactly the impression projected by Purser's treatment of the specific subject. A true exponent of the picturesque, the British landscape painter incorporated into the scene a variety of contrasting elements, such as two different specimens of nineteenth-century Greek architecture and a group of foreground figures dressed in eastern costumes. Purser arrived in Greece during a tour of that country and Italy in 1817-20, which he undertook with the architect John Sanders, acting as the latter's draftsman. Many British architects journeyed to Greece during the first quarter of the nineteenth century to investigate its architectural antiquities. Purser and Sanders were part of the team that during its explorations in the province of Boeotia were lucky to discover the monument of the Lion of Chaeroneia.

Reference
Benezit, 8:526; Thieme-Becker, 27:466; H. M. Colvin, *A Biographical Dictionary of English Architects, 1660-1840* (London, 1954), 196.

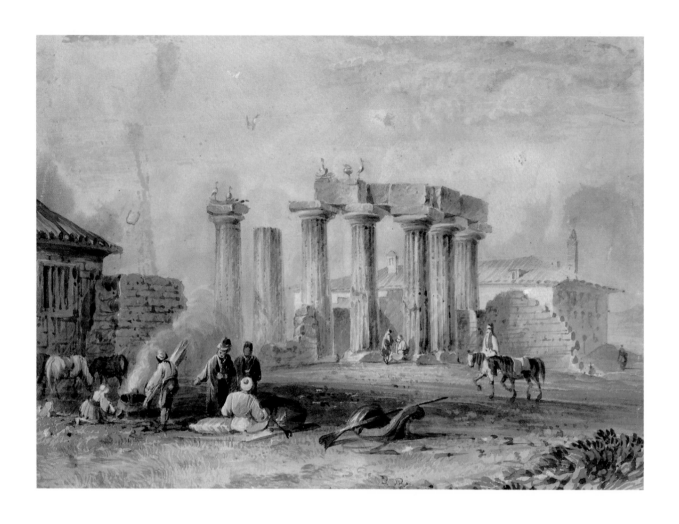

38. VIEW OF THE ANTIQUITIES OF ARGOS 1849

Edward Lear
(1812-1888)
Watercolor and sepia
on paper
22.5 x 35.5 cm
Inscribed: Argos
27 March 3 P.M.
1849 (88)
Inv. no. 24064

Argos, a historic city of the Peloponnese, is the oldest, continuously inhabited town in Europe. For nineteenth-century visitors, the most impressive site of the area was the ancient theater built at the end of the fourth century B.C. on the southeastern slopes of Mount Larissa, on the top of which stand the ruins of an ancient fortress. The remains of a Roman odeon, or concert hall, lie in front of the theater.

Lear, who ventured to Argos in March 1849, carefully organized his composition to convey the site's historical associations. From the ruins of the Roman odeon the eye is led to the theater's tiers of seats cut into the rock of the mountain side and to the top of the hill and its fortress. Then the eye plunges straight down to the right middle ground, where the presence of a few houses indicates the proximity of the modern town. This highly evocative view remains a remarkable specimen of Lear's descriptive style. Not only did he use firm, parallel sepia lines to record the features of the site, but he also managed to suggest the effect of the heavy rainstorm that, according to his journal, spoiled their visit that day.

Reference
Tsigakou, "Lear in Greece"; Tsigakou, *Travels of Lear*, 7-18; Noakes, *Edward Lear*, 106-108.

Argos. 3.8m.
27 March. 1849

(88)

101

39. VIEW OF ANCIENT SPARTA 1849

Edward Lear
(1812-1888)
Watercolor on paper
31.0 x 51.0 cm
Inscribed: 23 March 1849 (68) Sparta 5 1/2 P.M.—No end of ruins—a broad space of gulf between theatre and ruins
Inv. no. 24061

Once an important power in the Greek world, ancient Sparta proved a great disappointment to nineteenth-century visitors, for no trace remained of the legendary military state that had dominated Greek affairs. From the thirteenth century A.D., when the town was abandoned, until the new town of Sparta was founded by King Otho in the late 1830s, ancient Sparta stood uninhabited. Lear, however, does not seem to have been disappointed upon visiting the area in March 1849. "It is not easy to appreciate the beauty of the Greek scenery in a hasty visit. It is only on becoming conversant with the local features which combine exquisitely with the surrounding hills or plains that an artist perceives the inexhaustible store of really beautiful forms." Such notes in his *Journals of a Landscape Painter in Albania, etc.* (1851) draw a distinction between the experience of the visitor who spent some time on the site and that of the passerby. Lear seems to have realized that in certain classical locations the natural landscape was in itself revealing. Indeed, the appeal of Lear's views of ancient Greek sites lies in the successful evocation of the intimate association among diverse landscape features.

In this view of ancient Sparta, Lear depicted in his favored horizontal format the plain of Lacedaemon, where the city had once stood. The mighty and abrupt precipices of Mount Taygetus dominate the view seen from the hill of the ancient theater. Taygetus, the romantic symbol of Sparta, was a natural fortress, and the variety of its sharp summits gave it an imposing quality that was thought to embody power and pride, ideas that supposedly shaped the Spartan character. The fifth-century historian Xenophon related that Sparta had no walls, for "her ramparts were the men." It is no mere coincidence that Lear chose to emphasize the presence of that mountain. He was aware that to the perceptive visitor, Taygetus was eloquent testimony to the deserted site's Romantic associations. In terms of coloring he selected the hour of sunset, when all the elements of the scene were enveloped in warm purple hues that further add to the Romantic quality of the location.

Reference
Tsigakou, "Lear in Greece"; Tsigakou, *Travels of Lear*, 7-12; Noakes, *Edward Lear*, 106-108.

**40. VIEW OF MISTRAS
1849**

*Edward Lear
(1812-1888)
Watercolor on paper
26.5 x 41.5 cm
Inscribed: March 24 1849
cloudy Mistra
10 1/2 A.M. (70) —
A gray dark black day —
no mountain outlines
visible
Inv. no. 24062*

On a steep spur of Mount Taygetus, a few miles from modern Sparta, stands the ruined city of Mistras, founded in the thirteenth century A.D. by the inhabitants of Sparta. Divided from the mountain range by a sheer chasm, this naturally fortified site, which later became the seat of the last Byzantine emperor, epitomized the Romantic revival of the Middle Ages and was chosen by Goethe as the setting for the union of Faust and Helen. Nineteenth-century visitors could wander along the grass-covered streets, between the superb Byzantine churches and ruined palaces of the deserted city, to reach the Citadel, whose summit offered exquisite views over the plain of Lacedaemon.

Lear obviously followed this course on March 24, as a set of three drawings with the same date confirm (Benaki Museum, inv. nos. 24783-5). This rapid but nonetheless articulate drawing displays Lear's ability to express mass and panoramic breadth. The historic site depicted on the right was treated undramatically. Meanwhile, his realistic rendering of the modern architecture of the town and of the peasants' costumes in the foreground indicates that life goes on. Restrained grey and blue washes laid over the white paper convey the feeling of a "cloudy day," as indicated by his notes.

Reference
Tsigakou, "Lear in Greece"; Tsigakou, *Travels of Lear*, 7-18; Noakes, *Edward Lear*, 106-108.

41. A STREET IN THE TOWN OF PATRAS 1817

Hugh William Williams (1773-1829)
Watercolor on paper
27.5 x 43.5 cm
Inscribed:
Town of Patras—Greece
Inv. no. 22961

Patras, the capital of the province of Achaia, on the northwest coast of the Peloponnese, was for many centuries a cosmopolitan port that facilitated communications on the Adriatic Sea and with the Ionian Islands. Its ancient Acropolis is topped by the ruins of a Byzantine castle that was subsequently restored and rebuilt by Franks, Venetians, and Turks, which testifies to the city's long and turbulent history.

"Patras, the ancient Patrae, now a town of considerable size, stands upon a rising ground of gentle elevation…. The mountains behind…are lofty, of noble and pleasing forms, especially Mt Vodhia. The streets of Patras are very narrow. The roofs of the houses almost meet, which no doubt is intended for shade in this warm climate." So wrote the Scottish landscape painter Hugh William Williams in his *Travels in Italy, Greece and the Ionian Islands*, which was published in 1820, three years after his return from an extensive Greek tour. As the author pointed out in his introduction to the highly acclaimed publication, "The aim of the work was not to enter into discussions upon archaeology and history" but to describe the scenery and people as they appeared to him. Indeed, the book gives useful clues as to an artist's approach to the Greek scenery.

Williams was considered by his contemporaries to be the artist who captured most effectively the true spirit of "the glory that was Greece," and his Greek views earned him the name "Grecian Williams." This watercolor, executed with tinted washes over a carefully penciled outline, is basically a topographical scene, although Williams attempted to soften the rigidity of the outline of the houses and of Mount Panachaico, then referred to as Vodhia, which is seen in the background. The view is sensitive in drawing and is invested with an allusive quality present in the majority of his works. Williams later published *Select Views in Greece with Classical Illustrations* (1827-29), a set of plates made after his drawings from Greece and with quotations by ancient writers.

Reference
Benezit, 10:743-44; Thieme-Becker, 36:25; Navari, *Blackmer Collection*, 381; Tsigakou, *Rediscovery*, 23, 30, 108, 116-17, 122, 123, 200, pls. XVI, XXVI.

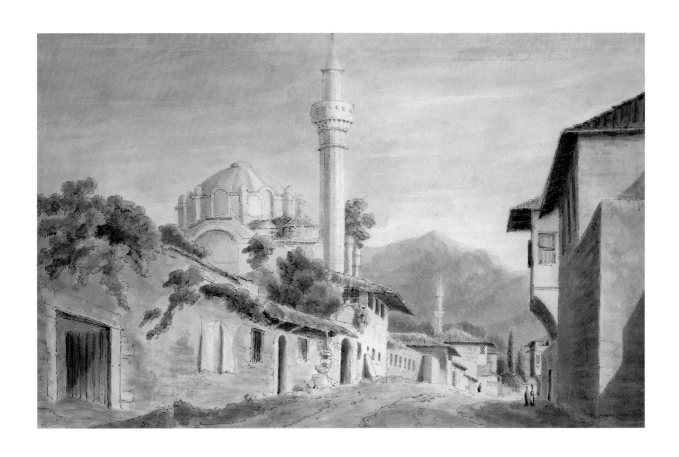

42. VIEW OF THE PORT OF CORFU 1826

Joseph Schranz
(1803-after 1853)
Watercolor on paper
28.0 x 46.0 cm
Inv. no. 22993

Corfu has benefited greatly from its geographical position three kilometers from the coast of Albania and Epirus and eighty kilometers from the Italian mainland. It served as the main seat of government of the Septinsular republic until the Ionian Islands came under the jurisdiction of Venice in the fourteenth century. The islands stayed in Venetian hands until the destruction of the Venetian republic in 1797. Afterwards they were occupied in succession by the French (1797-99), by a Russo-Turkish condominium (1799-1807)—an arrangement that ended as an exclusively Russian protectorate—by the French again (1807-14), and finally by the British in 1815. There they remained until 1862, after King Otho's abdication, when the British prime minister, Lord Palmerston, seized the opportunity to barter these islands for the establishment of a dynasty in Greece favorable to British interests. In 1863, Prince George of Denmark (whose sister had married the Prince of Wales) was proclaimed king of Greece, and the following year the Ionian Islands were incorporated into the Greek state.

Of all the Ionian Islands, Corfu was among those most favored by nineteenth-century travelers, not only for the beauty of its scenery but also for the comforts it offered the foreign visitor. Its main city is also one of the most attractive cities in Greece. When approached by sea, the sight of its ancient Citadel and its elegant mansions near the harbor complements the beauties of the island. This view by Joseph Schranz, taken from the Bay of Garitsa to the south of the town, opens on the left with a long, two-story mansion, the nineteenth-century Palace of Sts. Michael and George, which served as the residence of the British high commissioner. Then follows the Esplanade, which separated the town from the Citadel, an old fortress built in the sixteenth century by the Venetians on a promontory with two hills. Farther to the right a bridge spans the small canal dug between the Esplanade and the Citadel. The building in the form of a Doric temple overlooking the Bay of Garitsa was the Anglican church of St. George. In the distance the horizon is fringed by the unbroken range of the mountains of Albania and Epirus.

Schranz, a marine painter and lithographer, came from a family of landscape and marine artists on the island of Malta. He visited the Ionian Islands in 1826, together with his brother Giovanni. From about 1832, Schranz's permanent residence was Constantinople, from where he paid several visits to Greece in the 1840s. The elegant composition of this watercolor affirms the artist's meticulous style and use of bright colors. Thanks to his effective rendering of sunlight, Schranz brought together the townscape and the features of the surrounding countryside as he captured the play of sunshine over the water, giving a sense of serenity and calmness to the scene.

Reference
Tsigakou, *Rediscovery*, 199, pl. VIII; C. J. Attopardi, *The Schranz Artists: Landscape and Marine Painters in the Mediterranean* (Medina, Malta, 1987), 48-50.

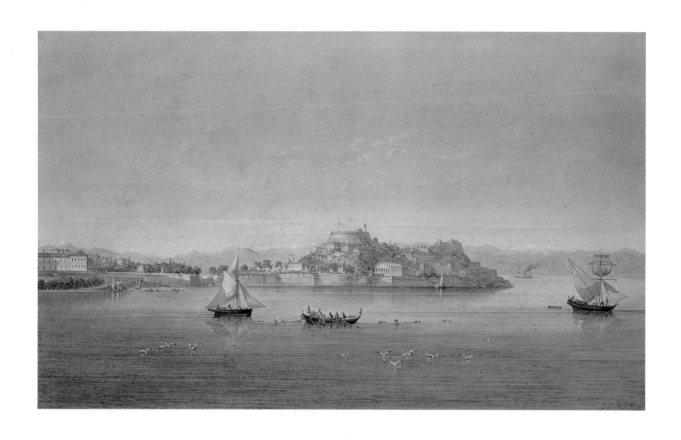

43. VIEW OF THE TOWN AND ISLAND OF CORFU 1826

Joseph Schranz
(1803-after 1853)
Watercolor on paper
19.2 x 31.0 cm
Inscribed: Schranz
Inv. no. 22996

Throughout its long history Corfu has enjoyed great prosperity. Its picturesque location and charming landscape were used as settings by many poets, from Homer to Shakespeare. Here was the Homeric kingdom where Ulysses was caught by a storm; it also served as the backdrop for *The Tempest*. Nineteenth-century visitors admired its great diversity of landscape. Schranz's view projects a favorable impression of the island's features, characterized by an indented coastline punctuated by bays and coves. Until the 1800s its countryside was exceedingly rich in vegetation, with thickly wooded hillsides, small fertile plains, and valleys covered with olive groves.

A sort of platform on the peninsula of Paleopolis to the south of Corfu town, from which this view was taken, offered extensive vistas over the island and became a favorite spot among artist-travelers. On the left is the island where the small convent of Vlachernes stands; the tiny island depicted farther to the right is referred to as "Ulysses' petrified boat." Visible beyond the scenic headland covered with thick olive groves is a general view of the town of Corfu, with its fortified promontory. This watercolor demonstrates Schranz's abilities as a consummate draftsman and sensitive colorist. Architectural details and topographical features were drawn with precision. Despite the complexity of masses and the undulating lines of the landscape, the space is unified. His use of color shows great refinement: gentle tones of soft greens and blues dominate the view, lending the scene an air of enchantment.

Reference
Tsigakou, *Rediscovery*, 199, pl. VIII; Attopardi, *Schranz Artists*, 48-50.

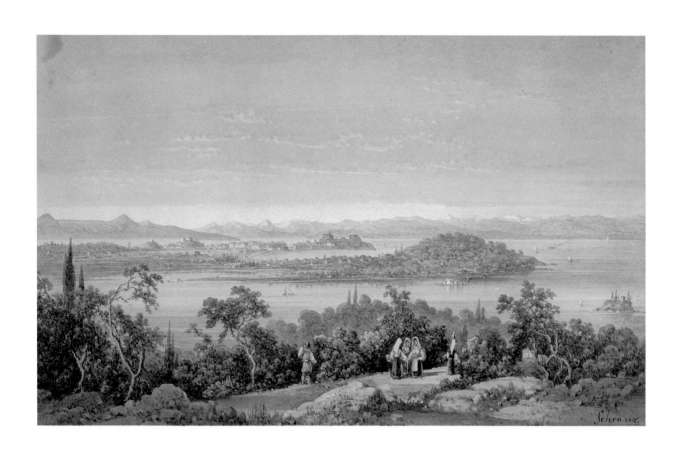

44. VIEW OF THE OLIVE GROVES ON CORFU 1863

Edward Lear
(1812-1888)
Watercolor and gouache
on paper
72.0 x 120.0 cm
Inv. no. 23984

This landscape resembles *View from the Hill of Santi Decca*, plate 5 in Lear's publication *Views of the Seven Ionian Islands* (see cat. no. 34). In the text accompanying the lithograph, Lear explains that "this drawing has been to illustrate the great beauty of the olive woods on the hills of the island. From Santi Decca you look down through endlessly varying groups of olive trees to the lake of Chalichiopoulo, the citadel, the Channel and the Albanian mountains." The artist was enchanted by the distinct scenery of the land. "The whole island is in undulations from the plain where the city is, to the higher hills on the west side; all the space is covered with one immense grove of olive-trees, so that you see over a carpet of wood wherever you look; and the higher you go, the more you see and always the citadel and the lake and then the channel with the Albanian mountains below."

Olive trees extend across the foreground and lead the eye into the distance, where the town, recognizable by its fortified peninsula, is perceived. Farther back the long range of the mountains of Albania rise just above the horizon line. Two olive trees frame the scene, their branches stretching out to act as viewpoints and to provide a sense of depth. In delicate, vaporous tones of silver-grey, blue, and green, Lear silhouetted the foliage and conveyed the visual effect of the elaborate play of light and shade on the olive woods. His figures are cleverly placed in a sunny spot of light yellow, their costumes brightly painted to break the monotony of the green areas. This work reveals Lear's talents as an outstanding topographer and a Romantic landscape painter. Moreover, in terms of composition and atmosphere, it approaches the type of landscape he favored. In his own words he preferred "a bright blue and green landscape with purple hills and unexplored forests…and all sorts of calm repose." This work is certainly not far from his ideal.

Reference
Tsigakou, "Lear in Greece"; Tsigakou, *Travels of Lear*, 7-18; Noakes, *Edward Lear*, 106-108.

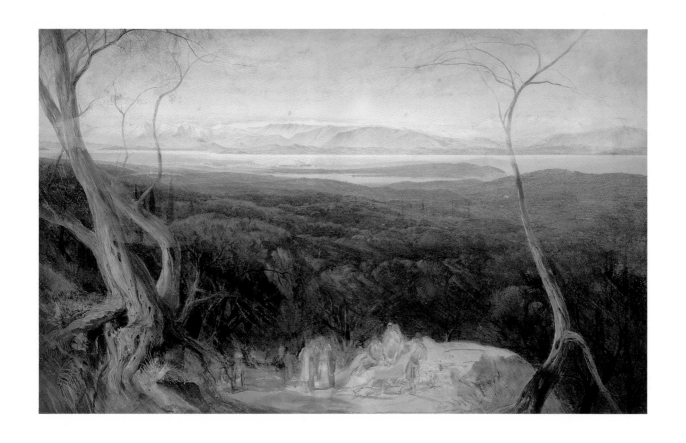

45. VIEW OF THE HEALTH OFFICE ON THE ISLAND OF LEUCAS Ca. 1820

Joseph Cartwright
(1789-1829)
Watercolor on paper
29.0 x 52.0 cm
Inv. no. 23976

The island of Leucas is in fact a peninsula joined to the coast of central Greece by a short isthmus. Given the name Santa Maura by the Venetians when they captured it in 1684, Leucas has generally shared the history of the other Ionian Islands.

This watercolor depicts the health office on Leucas. The British painter Joseph Cartwright spent several years on Corfu (1816-23) when he held the post of paymaster general to the British garrison. In 1821, Cartwright published a folio of aquatints entitled *Views in the Ionian Islands*, in which he attempted to illustrate, along with the scenery of the area, some aspects of the islanders' life. Plate 7, entitled *The Sanita or Health Office at Santa Maura*, seems to have been based on this watercolor. According to Cartwright's description which accompanies the plate, "This view of a Quarantine office is selected, to show the method of examining persons coming from countries suspected of plague." The people in the boats and those on the shore in the foreground are supposedly awaiting their inspection by the health officer before being sent to the lazaret. Another group of figures seen close to the house "are occupied in fumigating a letter." The man depicted at the window is "a traveller lounging away his irksome quarantine."

As in the majority of his works, Cartwright was here mainly engaged in describing the scene and the activities of the people involved. A multiplicity of objects dominate the view at the expense of the landscape. Nevertheless, this genre scene is faithful in its statement of the subject's facts. Its lack of pretention and its documentary value make it worthy of appreciation.

Reference
Benezit, 2:568; Thieme-Becker, 6:94-95; Tsigakou, *Rediscovery*, 29, 82, 104, 199.

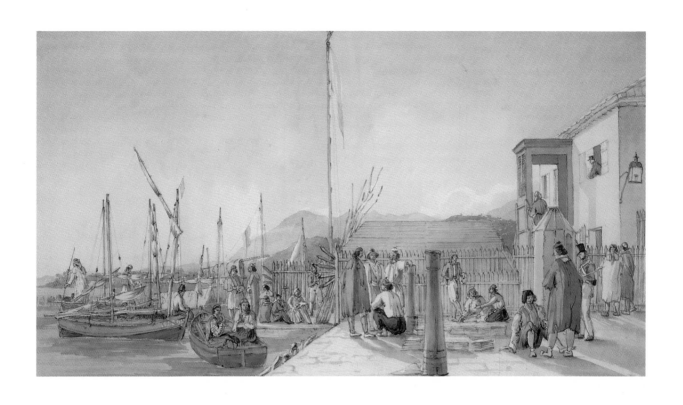

**46. VIEW OF THE
TOWN OF VATHY
ON THE ISLAND
OF ITHACA
Ca. 1820**

*Joseph Cartwright
(1789-1829)
Watercolor on paper
47.0 x 74.0 cm
Inv. no. 24068*

The island of Ithaca lies between the coast of central Greece and the island of Cephalonia, from which it is separated by a narrow channel. Its main attraction for nineteenth-century visitors was its association with the native country of Ulysses, the crafty hero of the *Odyssey*. Vathy was the capital and main port of the island. In Cartwright's *Views in the Ionian Islands* (see cat. no. 45), this image is almost identical to plate 8, *View of the Town and Harbour of Vathi, in Ithaca*. According to the artist's description in the relevant text, "This view is taken from the place where the people of the island transact their commercial deals, and bring down vegetables and other provisions for those who are in quarantine.... Behind is the town of Vathi."

Here, as in the previous watercolor, Cartwright created a faithful record with an eye for detail. Note, for example, the yellow flags on the ships that are supposedly in quarantine, or the various architectural details of the houses in Vathy, yet the composition lacks imaginative treatment. Cartwright does not seem to have been inspired by the island's Homeric associations or its picturesque scenery. As indicated in his publication, his interest in Ithaca, as indeed in the rest of the Ionian Islands, derived purely from their everyday aspects. Cartwright's Greek views convey a strong sense of locality and are almost scientifically authentic records of local life in nineteenth-century Greece.

Reference
Benezit, 2:568; Thieme-Becker, 6:94-95; Tsigakou, *Rediscovery*, 29, 82, 104, 199.

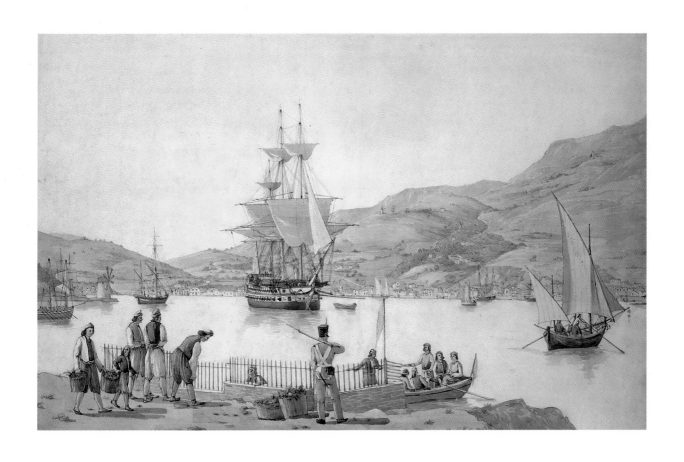

**47. VIEW OF THE
TOWN OF PARGA
Ca. 1820**

*Joseph Cartwright
(1789-1829)
Watercolor on paper
32.5 x 53.0 cm
Inv. no. 23978*

Parga, a small seaside town in Epirus on the western coast of Greece, opposite the island of Paxos, was seized in the sixteenth century by the Venetians and afterwards shared the general fate of the Ionian Islands. Unfortunately, when the town was under British protection, the English sold it in 1819 to Ali Pasha, the cruel ruler of Epirus. Parga was then destroyed, and the entire population emigrated to Corfu. In Cartwright's watercolor the city's landmark—the Venetian fortress—is shown atop the rocky hill on the right. It dwarfs the houses of the town below, which are picturesquely situated on the slopes. Several figures in the foreground further enliven the scene.

This rather conventional coastal landscape, with its inclusion of two men pulling out their fishing boat, is typical of traditional marine paintings. Thanks, however, to the solidity of the composition and the successful rendering of the figures and their surroundings, Cartwright cleverly disguised the artificiality of the scene and created a pleasant picture of a Mediterranean town.

Reference
Benezit, 2:568; Thieme-Becker, 6:94-95; Tsigakou, *Rediscovery*, 29, 82, 104, 199.

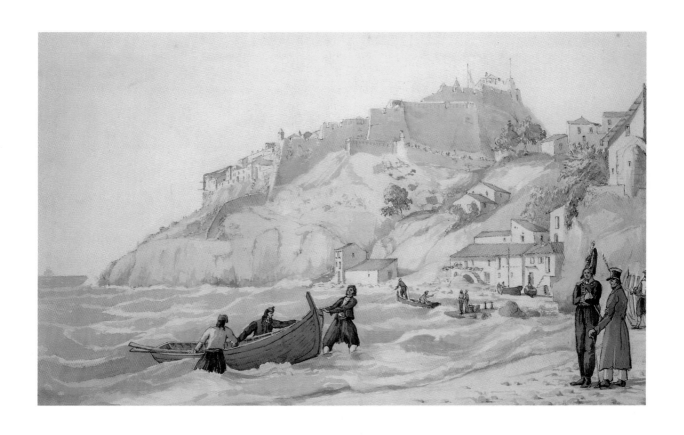

48. VIEW OF THE TOWN OF THEBES 1819

Hugh William Williams
(1773-1829)
Watercolor on paper
47.0 x 68.5 cm
Inscribed (lower right):
H. W. Williams 1819
Inv. no. 25194

Occupying the site of the ancient Acropolis of Cadmeia is Thebes, the chief town of Boeotia. During the heroic times that followed its foundation, Thebes was the scene of many dramas, which inspired some of the greatest Greek tragedies, such as *The Seven Against Thebes* by Aeschylus and *Oedipus Rex* and *Antigone* by Sophocles. In the nineteenth century, however, the city presented the visitor with nothing but a name and a plentiful countryside.

Seen in the foreground are the banks of the river Ismenos, not far from the spring where Oedipus washed off the blood of his father. In the nineteenth century, the banks of the Ismenos were lined by bushes and dense foliage, as shown in the watercolor. The city of Thebes appears in the middle ground. The ancient aquaduct that supplied the town with water until the late 1800s is visible on the left. The elegant outline of Mount Helicon, which in antiquity was the dwelling place of the Nine Muses, fills the background.

Here, as in most of his Greek views, Williams tried to invest the scene's topography with an evocation of nostalgia for the bygone age of Greece. To express better this sentimentality, Williams, like most of his contemporary artists, resorted to established pictorial conventions that combined the representation of nature and ruins as seen in the works of Claude Lorrain and Nicolas Poussin, the great seventeenth-century masters of classical landscape painting. Indeed, in his *Travels in Italy, Greece and the Ionian Islands* (see cat. no. 41), Williams confessed, "The scenery in Greece demands our most careful study. Unless we are familiar with what has been discovered by Nature's favourite sons, she will not present those electrifying truths, which flush upon the mind when studying her not as *she is*, but as seen through the medium of works of genius…. The works of Nicolo Poussin [or Claude Lorrain] agree with the character of [Greece]…. The simple dignity of form and colour, perceptibly in the works of these great men, enters into the spirit of its story, and calls forth corresponding sentiments."

This image of Thebes was obviously inspired by Claude's views of the Roman campagna, which offer a world of calm and beauty whose fleeting glow of light creates a harmonious setting for the location's legendary past. Here, all anecdotal elements of the spacious and verdant landscape are integrated by means of light effects, which give way to a vast resplendence.

Bordering between dream and reality, this vision of Greece perfectly matched that held by Europeans in the early nineteenth century. When reviewing Williams' exhibition of Greek landscapes, held in Edinburgh in 1822, the critic William Hazlitt wrote, "These watercolours deserve very high praise. Some splenetic travellers have pretended that Greece was dry and barren. But it is not so in Mr. Williams' authentic draughts; and we thank him for restoring to us our old, and as it appears, true illusion." This Greek view is a poetical image with no reference to a specific location or country. Yet similar scenes of Greece were challenged after the first quarter of the nineteenth century, when European imagination was confronted by such realities as the Greek War of Independence.

Reference
Benezit, 10:743-44; Thieme-Becker, 36:25; Navari, *Blackmer Collection*, 381; Tsigakou, *Rediscovery*, 23, 30, 108, 116-17, 122, 123, 200, pls. XVI, XXVI.

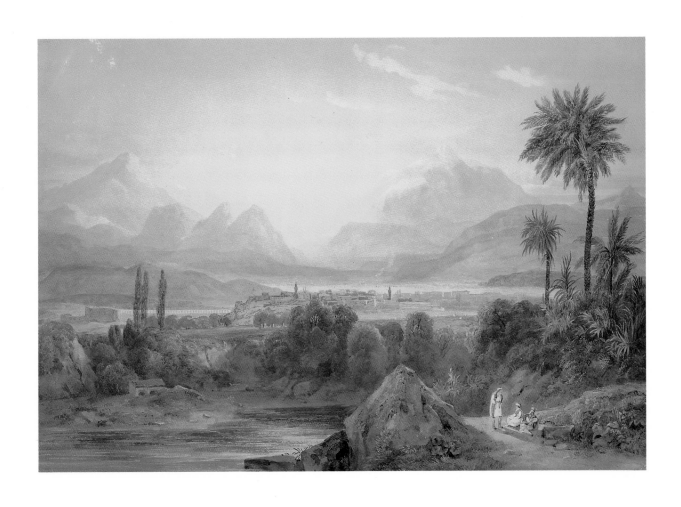

49. VIEW OF THE TOWN OF LEVADIA Ca. 1820

Joseph Cartwright
(1789-1829)
Watercolor on paper
36.5 x 55.5 cm
Inv. no. 23975

Ascending the northeast slope of Mount Helicon, the nineteenth-century traveler reached Levadia, the only other town in Boeotia comparable in importance with Thebes. But whereas Thebes was a poverty-stricken village in the 1800s, Levadia was a prosperous town set in idyllic scenery. There, the classically minded tourist could visit the site of the Oracle of Trophonios, which in ancient times was second in repute only to that of Delphi itself.

Cartwright's view presents a town that extends over a large area at the foot of a precipitous slope of Mount Helicon, which is crowned by a ruined castle. The center of Levadia is filled by the torrent that issues from the mountain and falls over the rocky bed in the middle ground. In this convincing topographical view, Cartwright managed to convey the true character of the place, the gracefulness of its natural scenery, the picturesque aspects of its rustic architecture. Local incidents, such as the women washing in the stream or the storks sitting on the chimneys, impart a narrative quality to the view and strengthen the sense of immediacy. The figures in the foreground were drawn with such exactitude that the various garments of their costumes can be discerned. The man wearing a kind of top hat is an upper-class Greek or a senior municipal official. In nineteenth-century Greece social status was often indicated by the individual's headgear. All in all, Cartwright's watercolor is a pleasant composition brimming with life and variety.

Reference
Benezit, 2:568; Thieme-Becker, 6:94-95; Tsigakou, *Rediscovery*, 29, 82, 104, 199.

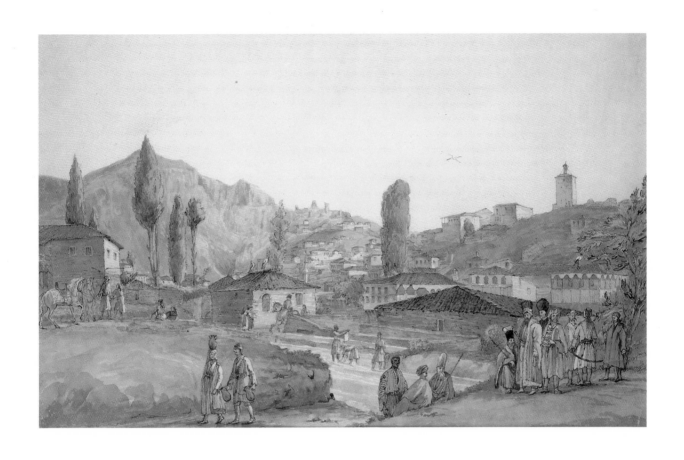

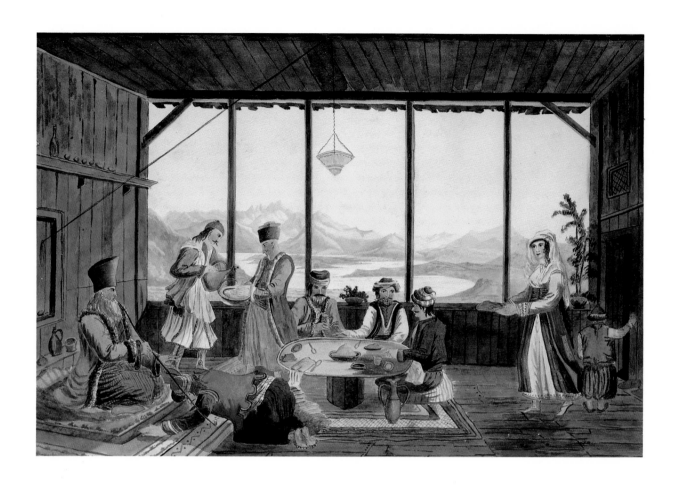

50. DINNER IN A GREEK HOUSE IN THE VILLAGE OF CHRISSO 1801-1805/6

Edward Dodwell
(1767-1832)
Watercolor on paper
25.0 x 39.5 cm
Inv. no. 23056

Situated in the ancient territory of Phocis and on the southern side of Mount Parnassus, the village of Chrisso occupied the site of the Homeric Krissa. For nineteenth-century travelers, the village's main attraction was its location on the slopes of the celebrated Mount Parnassus, only a few miles from the deserted site of Delphi.

Edward Dodwell, who visited Chrisso on his way to Delphi, was offered hospitality at the house of the Greek bishop. This drawing is almost identical to the plate entitled *Dinner at Crisso in the house of the Bishop of Salona*, which is included in *Views in Greece*, Dodwell's folio of aquatints (see cat. no. 18). In the accompanying text, the artist related the scene in great detail. This description testifies to Dodwell's ardent antiquarianism, for he tried to discover and identify classical customs and observances in nineteenth-century life. As he explained, "The Bishop of Salona gave us reception in his house…. This circumstance afforded us a favourable opportunity of observing some customs which merit commentation as instances in which classical usages have survived. Before sitting down to dinner and after we rose from table we performed the ancient ceremony of washing the hands, which is mentioned by Hesiod, Homer and other authors…. A tin bason is taken round by a servant."

The bishop is seated in the left foreground. To his left the servant who takes round the "bason" helps a Greek gentleman—who is recognizable by his top hat (see cat. no. 49)—wash his hands. Dodwell's antiquarian description goes on: "We dined at a round table supported on one leg, or column, like the *monopodia* of the ancient Greeks."

Antiquarianism motivated many travelers to venture to Greece, where they usually wandered around the country totally indifferent to its contemporary situation. This was not the case with Dodwell. Although he was a prototype of the classically educated visitor, his choice of pictorial subjects covered a wide range of Greek sites, not all of them antique. Here he created a lively and meticulous representation of a Greek domestic scene.

Reference
Benezit, 13:605; Thieme-Becker, 9:361; Navari, *Blackmer Collection*, 107-108; Tsigakou, *Rediscovery*, 26, 28, 85, 110, 142, 143, 157, 162, 178, 199, 200.

51. VIEW OF THE VALLEY OF TEMPE 1801/2-1806

Sir William Gell
(1774-1836)
Watercolor on paper
19.0 x 26.5 cm
Inv. no. 22946

After journeying through the dusty plains of Thessaly, travelers would be relieved to reach the shady Valley of Tempe, a narrow lowland about nine kilometers long between Mounts Ossa and Olympus. The ancients, who thought highly of the beauty and freshness of its landscape, which differs so completely from that of any part of Thessaly, attributed its formation to Poseidon. Also Apollo was said to have purified himself in the water flowing there after he killed the monstrous Python at Delphi.

The legendary history of the site and its enchanting landscape made the Valley of Tempe an attractive addition to the artist-traveler's sketchbook. In this view Sir William Gell produced an accurate record of the area. The river Peneus flows in the middle of a narrow pass that courses between precipitous rocks on each side and beneath overhanging trees. The low viewpoint chosen by the artist makes the daunting cliffs look even more imposing, and the receding line of rocks contribute to the impression of great depth. Together, these elements combine to make this one of the most effective Greek compositions by "Classical Gell" (see cat. no. 32). In terms of color, the subdued light and the cliffs, which are silhouetted in delicate, vaporous tones of green and blue, impart a lyrical feeling to the scene. It is remarkable how with an economy of means Gell evoked the romanticism of the site.

Reference

Benezit, 4:662; Thieme-Becker, 13:366; Navari, *Blackmer Collection*, 142-44; Tsigakou, *Rediscovery*, 26, 30, 183, 193, pl. XI.

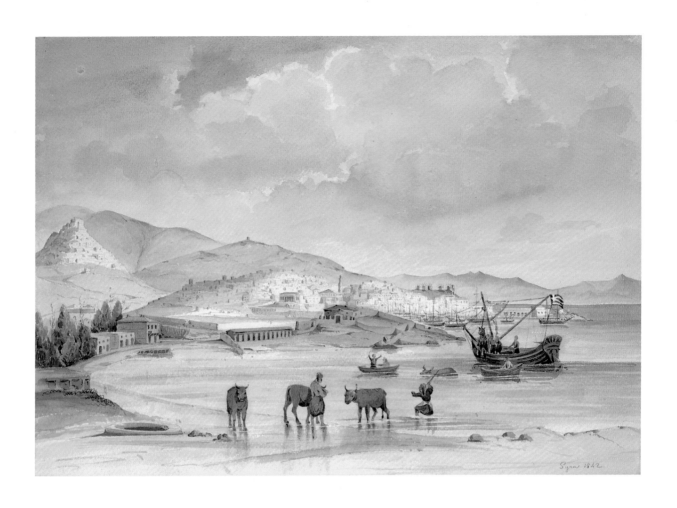

52. VIEW OF THE TOWN OF HERMOUPOLIS ON THE ISLAND OF SYROS 1842

Wilhelm von Weiler
(act. 1830s-1840s)
Watercolor on paper
33.0 x 45.0 cm
Inscribed: Syra 1842
Inv. no. 24008

Travelers who possessed the time and inclination to deviate from the conventional itinerary often undertook a tour of the islands of the Aegean Sea. Most of these islands offered only limited facilities to the nineteenth-century visitor, and little had been excavated of those places renowned in antiquity. Tourists therefore preferred to spend only a few hours on each island, enjoying the clarity of their forms and the variety of the Greek coastline while cruising among them.

Due to its importance as a commercial center, the island of Syros could provide adequate amenities to foreign visitors. Syros, which for many centuries was a Venetian possession, developed into a bastion of the Latin faith. Shortly before the 1821 War of Independence, this island experienced considerable prosperity, and its harbor became a hive of trading activity. During the Greek War, refugees from the neighboring islands sought asylum there, and in the Othonian period they built a new town, which became the island's capital and was given the name Hermes, after the god of commerce. Until the end of the century Hermoupolis flourished as a commercial and cultural hub.

King Otho's policy to develop his young kingdom led to the drawing up of new city plans for the country's major cities, such as Nafplion, Patras, Argos, Sparta, Chalcis, and Syros. Responsible for the design and execution of the town plan of Hermoupolis was the Bavarian engineer Wilhelm von Weiler (see cat. no. 35). Weiler was established on Syros between 1837 and 1842. While he was actively implementing the town plan, he also designed and constructed several important public buildings there.

Seen from a mole to the south of Hermoupolis, the town extends along the port against a mountainous countryside. The conical mound covered with houses that rises prominently at the left is the medieval town of Ano Syros, built in Venetian times on the hill of St. Giorgio. Hermoupolis appears in the middle ground, stretching between Ano Syros and the waterfront. In this skillful, picturesque composition, Weiler achieved a fluidity of design that did not alter the individual character of the scene. All topographical and architectural details were executed with care, and the play of light effects was rendered convincingly. This watercolor remains an interesting document of the early years of Hermoupolis, which served as the main port of post-revolutionary Greece until the last quarter of the nineteenth century, when it was overtaken by Piraeus.

Reference
Travlos and Kokkou, *Hermoupolis*, 75-76.

53. THE GREEK FRIGATE *TERPSIHORE* 1820

Antoine (or Joseph-Ange-Antoine) Roux (1765-1835)
Watercolor on paper
51.5 x 69.5 cm
Inscribed: Ant. Roux
March 1820
Below (in French):
The Terpsihore built
in Hydra in 1819 by
Manolis Tombazis son
of Nicolas
Inv. no. 25522

Greek history is inextricably linked to the sea. Its fame as a maritime nation goes back a great many centuries. From the eighteenth century onwards Greek participation in the Ottoman Empire's sea trade grew rapidly in most Turkish-occupied areas. Coastal towns and islands, such as Missolonghi, Patras, Spetsae, and Hydra, developed into important naval centers. Greek shippers took full advantage of the Russo-Turkish treaty of Kuchuk Kainarji (1774) and of the continental blockade imposed during the French Revolution, which enabled them to extend their operations to central and northern Europe and to southern Russia. Seamen who braved the dangerous conditions of navigation and repeatedly broke through the European blockade with their grain ships became especially daring and experienced in warfare. Moreover, the dissemination of new ideas throughout the Greek-speaking world then under Turkish rule led to a cultural efflorescence that has become known as the "neo-Hellenic Enlightenment," which culminated in the Greek War of Independence in 1821.

In this image a two-masted sailing ship flies the flag of Hydra, identified by its highly decorative emblem of a large white cross above a crescent, flanked by a lance and an anchor. The inscription below the crescent reads (in Greek) Freedom or Death. The depiction of the flag was more than just a visual record; it could be invested with nationalistic connotations, considering the historical situation in Greece. In the early nineteenth century each island had its own banner, with the cross as a common symbol. The motto Freedom or Death signaled the general watchword for the Greek Revolution, which broke out only a year after the completion of this watercolor.

Another small flag on the top of the mast bears the ship's name, *Terpsihore*. According to the artist's inscription on the panel below the picture, the ship *Terpsihore* was built on the island of Hydra by Manolis Tombazis, son of Nicolas. Tombazis (1784-1831) came from one of the most famous naval families of Hydra. During the Greek War of Independence he commanded the Hydra naval squadron under Andreas Miaoulis (see cat. no. 54), and afterwards he was nominated to represent Hydra in the Greek National Assembly.

The French artist Antoine Roux, a member of a well-known family of marine artists, drew here a faithful portrait of a ship. To give a sense of location to his composition, Roux chose to depict the frigate *Terpsihore* sailing past the islet of Bourtzi on its way out of the harbor of Nafplion. Bourtzi, seen to the left of the ship, is situated in the Bay of Nafplion in the Peloponnese (see cat. no. 69).

Reference
Benezit, 9:144; Thieme-Becker, 29:122; *Sailing Ships from Galaxidi* (Galaxidi, 1987), 44-45; A. Delivorrias, ed., *Greece and the Sea* (exh. cat.; Amsterdam, 1987), 338, 344.

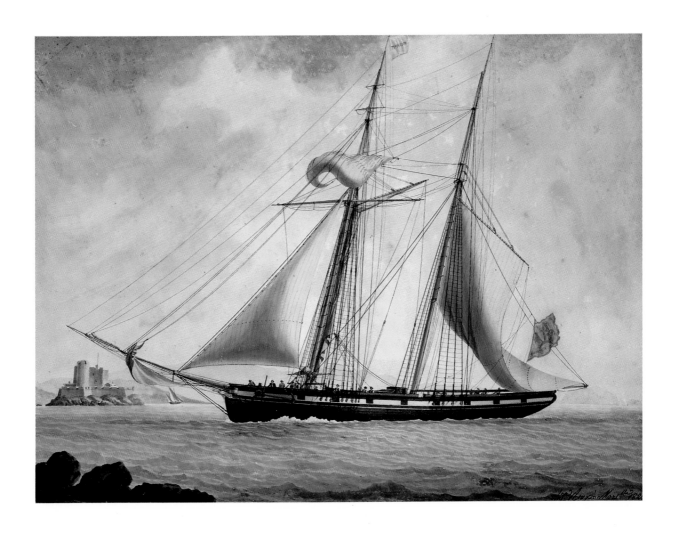

54. THE GREEK BRIG *ARES* 1881

François-Geoffroy Roux
(1811-1882)
Watercolor on paper
50.0 x 70.0 cm
Inscribed: François Roux
Marseilles 1881
Inv. no. 23950

Ancient Greek names were popular among Greek ship owners, especially during the years of Turkish occupation, because such references strengthened their sense of national heritage and identity. *Ares* was the flagship of Admiral Andreas Miaoulis (1769-1835), a native of Hydra who was commander in chief of Greek naval forces throughout the revolution and was responsible for many of the Greek fleet's victories. At the end of the war Miaoulis was one of three Greek representatives sent to Munich in 1832 to offer the Greek throne to Prince Otho of Bavaria.

Miaoulis' flagship became a legend throughout the Mediterranean. It would have been quite impossible for the Greek War of Independence to succeed without the cooperation of the naval forces furnished by the islands of Hydra, Spetsae, and Psara. The island fleet contributed decisively to the consolidation and eventual success of the war, because it remained essentially invincible to the end.

François-Geoffroy Roux, the son of Antoine Roux (see cat. no. 53), belonged to that same renowned family of French marine painters established in Marseilles. Their works, usually illustrations of ships, were particularly prized by foreign visitors, who acquired them as souvenirs. This watercolor of the *Ares* must have been commissioned by its Greek owner. The ship occupies most of the picture plane as it sails in the open sea. Another vessel moves past it on the right. They both fly the national Greek flag with blue and white stripes. One more ship can be discerned on the horizon to the right. The artist depicted in great detail the decorative elements of the brig, such as the famous figure head of Ares, the god of war, which is a fine specimen of Greek traditional woodcarving. (Today this piece is exhibited in the National Historical Museum of Athens.) Typical of Roux's works, these ships afford a handsome sight, with their sails open wide under a vividly colored sky.

Reference

Benezit, 9:145; Thieme-Becker, 29:122; *Sailing Ships from Galaxidi*, 44-45; Delivorrias, *Greece and the Sea*, 338, 344.

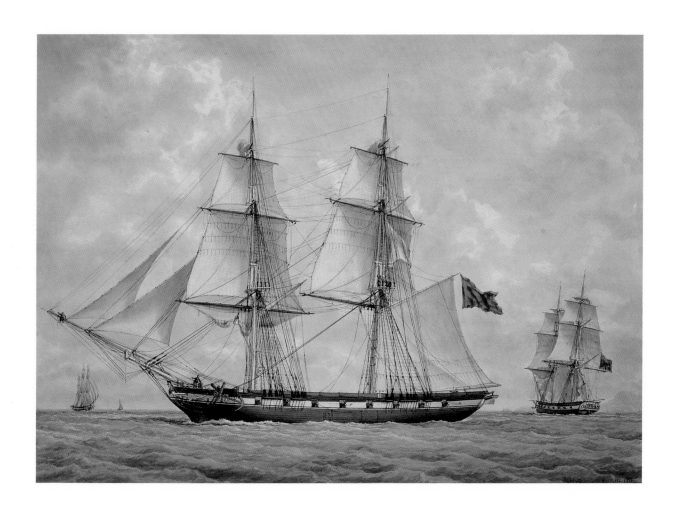

55. GREEK SAILORS BY THE SEASHORE 1831

Carl Wilhelm von Heideck (or Heidegger or Heydeck)
(1788-1861)
Oil on zinc
35.5 x 40.0 cm
Inscribed (lower right):
C. v. hdk 1831
Inv. no. 11180

Even though Greece is surrounded by the sea and its archipelago consists of 3,000 isles and islets, Greek seamen did not achieve modern prominence until the years of the War of Independence. Then some of the country's most spectacular victories were associated with the courage and amazing naval abilities of Greek sailors. Quite naturally, the life of Greek seaman captured the imagination of nineteenth-century writers and artists alike.

The German baron Carl Wilhelm Freiherr von Heideck (or Heidegger), in addition to being a talented amateur draftsman, enjoyed a distinguished military career. In 1826, he was sent to Greece by King Ludwig I of Bavaria as commander of the corps of military advisers who were to instruct the Greeks in the tactics of war. When the conflict was over, the Greek government appointed him commandant of the city of Nafplion, the first capital of liberated Greece. Heideck left Greece in 1829, only to return three years later as one of the three Bavarian regents who accompanied King Otho. After his return to Germany in 1835, Heideck painted genre and landscape scenes of the countries he had known, including a number of Greek subjects. The date inscribed on this picture indicates that, like most of his oil paintings, this was executed in his Munich studio after drawings he had made on the spot.

This picture illustrates Heideck's strong talent for genre and the picturesque. He had a marvelous eye for detail and a feeling for composition and atmosphere. His figures are spirited and carefully placed. Although the wildness of the scenery may allude to the sumptuous coastal images that were common in seventeenth-century landscape painting, such as those by Claude-Joseph Vernet (1714-1789), there is little heroic about this particular scene. Indeed, since Greek naval achievements were no longer a contemporary event, Heideck chose to represent an incident from the daily life of Greek seamen to suggest their vigor, gaiety, and adventurous lifestyle.

Reference
Benezit, 5:461-62; Thieme-Becker, 16:253-54; Delivorrias, *Greece and the Sea*, 338; Tsigakou, *Rediscovery*, 63, 138, 154, 202.

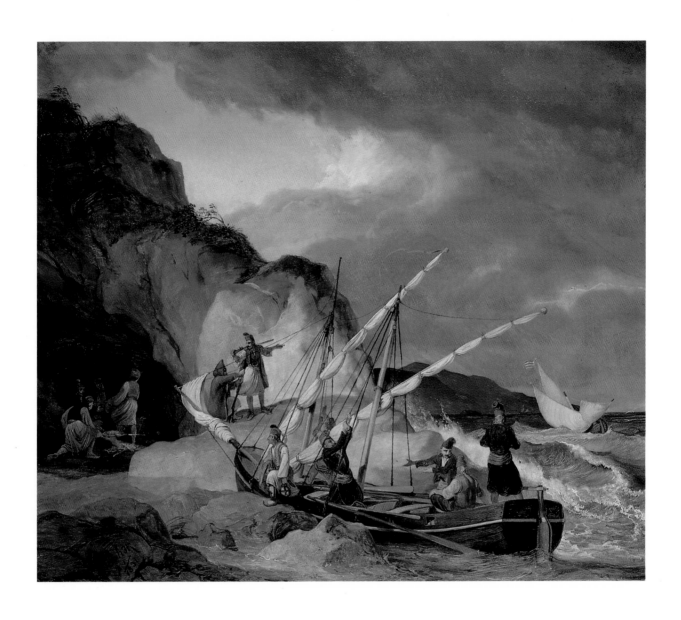

56. THE DEATH OF MARCOS BOTSARIS 1836/9

Filippo Marsigli
(1790-1863)
Oil on canvas
58.5 x 72.5 cm
Inv. no. 8969

The Suliote leader Marcos Botsaris (1790-1823) exhibited extraordinary bravery and military skills during the struggle of the Suliotes against Ali Pasha, the ruthless Albanian ruler of Epirus. Following the devastation of his homeland of Suli in 1803, Botsaris fled to the French-held Ionian Islands, where he served in the French army. In 1821, he joined the revolution on mainland Greece as the leader of the troops in Missolonghi (see cat. no. 57). When that town was besieged the following year, Botsaris organized its defense. Part of his strategy was to prevent the further advance of the large Turkish army, which was heading towards Missolonghi, by attacking at night its encampment in the nearby valley at Karpenissi. The operation was successful, but unfortunately Botsaris was mortally wounded during the conflict. He was carried back to his headquarters by his devoted soldiers and died that same August night.

While his heroic death in action conjured up in European philhellenic minds a parallel with an illustrious ancestor—King Leonidas of Sparta, who died with his three hundred soldiers in their effort to stall the invading Persian army—Botsaris' wounding in the heat of the battle fired the imagination of artists. Botsaris entered the realm of philhellenic imagery as the personification of liberalism and the symbol of the fight against absolutism. The subject inspired Italian artists in particular during a time when their own homeland was experiencing the *Risorgimento* (uprising) against Austrian absolutism.

Filippo Marsigli, a history painter, from 1833 onwards held the position of professor at the Academia de Belle Arti in his native Naples. This painting is a smaller version of a canvas that Marsigli executed in 1836 but which no longer exists. (The National Gallery in Athens possesses a drawing of the same subject.) Two groups of figures balance the composition: on the left is a group of agitated, ferocious Turks led by two horsemen; on the right Greek soldiers with dignified expressions of grief cluster around their wounded leader, who lies in the arms of his *palikars*. In the center two Greek soldiers with their swords raised step over the body of an expiring Turk and hold the enemy riders at bay. Their fierce and resolute gestures leave no doubt that the enemy will never take away the body of Botsaris. The scene pulsates with drama and movement.

It seems that Marsigli used as historical documentation an account of the event described in a popular book of the time, *Histoire de la regénération de la Grèce* by F.C. H. L. Pouqueville (4 vols., Paris, 1824). "Marcos Botzaris is hit in the head and falls unconscious.... The Turks having rallied to claim Botzaris's head, a terrible fight begins around the hero lying on the ground. Twenty-six Souliots are killed around their chief; six are seriously wounded; and all, pooling their efforts, cover the retreat of Athanase Touzas who had succeeded in removing the cherished hero from the battlefield." Here, Marsigli's concern was to capture the highly dramatic moment of the struggle over the dying warrior's body and the psychological tension of his devoted companions. Instead of painting a pictorial account of a historic event, the artist managed to create a powerful and romantic scene in which personal sentiment is intertwined with patriotism and heroism.

Reference
Benezit, 7:204; Thieme-Becker, 24:142-43; C. Spetsieri-Beschi and E. Lucarelli, *Risorgimento Greco e Filellenismo Italiano* (exh. cat.; Rome, 1968), 318-19; N. Athanassoglou-Kallmyer, *French Images from the Greek War of Independence 1821-1830* (New Haven, Conn., 1989), 41-53.

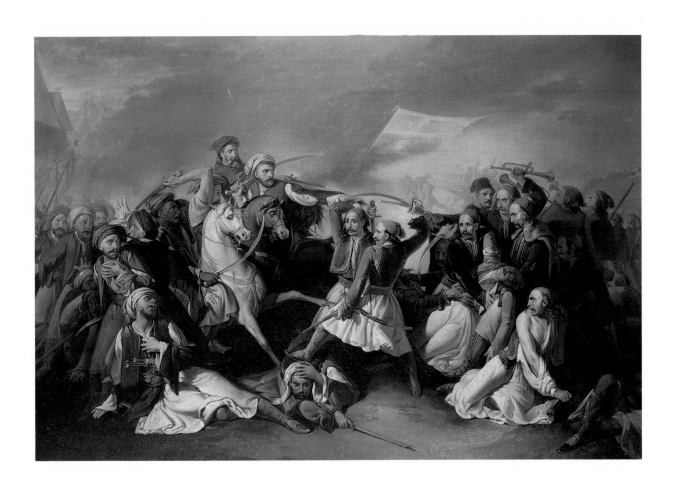

57. LORD BYRON'S OATH ON THE TOMB OF MARCOS BOTSARIS
Ca. 1850

After Ludovico Lipparini
(1800-1856)
Oil on wood
16.0 x 19.0 cm
Inv. no. 9009

The numerous paintings, prints, poems, and theatrical plays that were inspired by Marcos Botsaris and produced in the 1820s and 1830s testify to the Greek hero's notoreity. Lord Byron held in great esteem this noble personality who was worshiped by his comrades. He described Botsaris as having "the character of a good soldier, and an honourable man, which are not always found together, or indeed separately." It was through Byron's verses that the current situation in Greece was revealed to many of his contemporary artists. After touring Greece from 1809 to 1811, Byron returned to England with his manuscript of *Childe Harold's Pilgrimage*, the publication of which in 1812 took London by storm. The sensational, doomed aristocrat identified with the author established the Romantic hero once and for all. Undoubtedly Byron's poetry furnished his fellow artists with ample subject matter open to Romantic interpretations. At the same time, it heightened philhellenic sentiments in Europe, because it forced the condition of modern Greece upon the European imagination and conscience.

A liberal in spirit and a satirist of his society, Byron first visited Greece as a romantic young wanderer in the ancient country of myth and tale. Unlike most of his contemporaries, however, the poet did not perceive that country to be only the timeless setting of a heroic world. In Byron's stanzas, Greece was more than the deserted abode of nymphs and classical figures—it became a passionate, colorful land filled with life and peopled by human beings who deserved better than their fate. While interpretations of Byron's Greek maids and Suliote *palikars* replaced Virgilian shepherds in the exhibition rooms, the locations associated with his poems and travels soon rivaled Greek classical sites in attraction. The name of Missolonghi came to symbolize the aspirations of all European sympathizers with the Greek War of Independence. In 1823, Byron was sent to Missolonghi as a member of the Philhellenic London Committee to offer his services to the Greek cause. Upon landing in Greece he received a letter from Botsaris, announcing that he was longing to meet his Excellency. The poet was equally thrilled because he was an admirer of the brave Suliote leader. Unfortunately, the meeting never came about: a few days later, Botsaris was killed and buried in Missolonghi (see cat. no. 56).

The Italian portrait and history painter Ludovico Lipparini depicted a number of philhellenic subjects, including *The Death of Botsaris*. Here, as in the almost identical but larger version by Lipparini dated 1850 (Museo Civico, Treviso), the artist tried to recreate the scene with a high degree of accuracy. Byron, dressed in his favorite Suliote costume, solemnly takes an oath before the people of Missolonghi and the military and religious leaders of the Greek Revolution. When the poet died a few months later in April 1824, his death fanned the flames of philhellenic enthusiasm in Europe and America. In the consciousness of liberals the world over, this event acquired a symbolic value as a contribution to what Byron himself called the "very poetry of politics," that is, the conversion of Romantic ideals into action. Memories of the poet's self-sacrifice evoked by this picture, which was executed twenty-five years later, must have touched the hearts of nationalist Italians as a clear allusion to their own struggle for Liberty or Death.

Reference
Benezit, 6:687; Thieme-Becker, 23:266-67; Tsigakou, *Rediscovery*, 54, 55, 66, 67, 196; F.-M. Tsigakou, *Lord Byron in Greece* (exh. cat.; Athens, 1988), 25, 97-98.

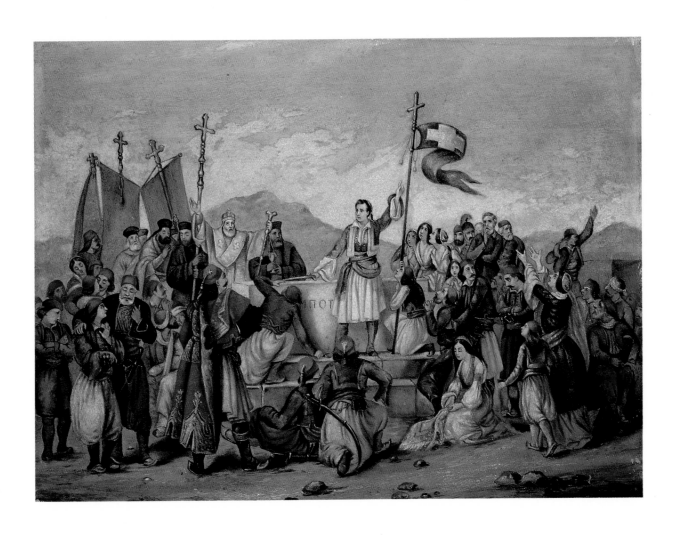

58. MISSOLONGHI FUGITIVES
Ca. 1830

Jean Michel Mercier
(1788-1874)
Oil on canvas
37.5 x 58.5 cm
Inscribed (lower right):
Mercier
Inv. no. 12944

Situated on the edge of a wide, stagnant lagoon near the Gulf of Patras, Missolonghi became known as the "bastion of Greek freedom." As a strategic outpost, the town formed the center of military campaigns in western Greece. When first besieged by the Turks in 1822, its inhabitants forced the enemy troops to retire. In April of 1825, a Turko-Egyptian army laid siege to Missolonghi, almost the last town still held by the insurgents on the mainland. As the area lacked natural defenses, the enemy rightly believed that a tight blockade enforced from both land and sea would bring about its quick surrender. Nevertheless, operations conducted by the brave garrison of Missolonghi, along with the active participation of all its citizens, who upheld an incredibly high morale, resulted in successive victories over the besiegers during the first six months. From the start, however, food and ammunition were in far shorter supply than the population's actual needs. At the beginning of the following year, the scarcity of food became as severe as the victorious repulsion of repeated attacks was impressive. Despite their hopeless situation, the citizens of Missolonghi rejected the enemy's treaty of surrender.

Disease and hunger had reduced the original 4,000 defenders to half when, after a year of resistance, they attempted a desperate escape. Only one-third of the soldiers and a few women and children succeeded in fighting their way through the troops to safety. Those too old, wounded, or weak from hunger to take part in the exodus sought refuge in the powder magazines, which they set on fire when the enemy marched in. World opinion was deeply shaken by the epic of the twelve-month siege. The story of Missolonghi became widely known through accounts in the press, narratives in contemporary publications, and numerous poems and paintings.

Visual imagery related to Missolonghi generally centers around the defenders' last communion before their flight, the firing of the powder magazines, the savage slaughter of the remaining inhabitants, or the plea for assistance directed to the mighty of the world, as in Eugène Delacroix's *Greece in the Ruins of Missolonghi*. The French artist Jean Michel Mercier chose to depict a family of survivors on board a fishing boat fleeing from their city, seen on the right in flames. A man holding a musket stands on the front of the boat; two younger men row at the back. Before the standing man a prominently portrayed woman holds a child on her lap while she watches another baby who lies next to her. The historical event bears a tinge of sentimentality. Despite this, the warm palette used by the artist and his masterful treatment of light lend the scene a dramatic intensity. This representation of the victims of war—of induced homelessness, of innocent humanity being persecuted by evil forces—must have generated a strong emotional response among nineteenth-century viewers.

Reference
Benezit, 7:340; Thieme-Becker, 24:408-409; Athanassoglou-Kallmyer, *French Images from Greek War*, 67-81.

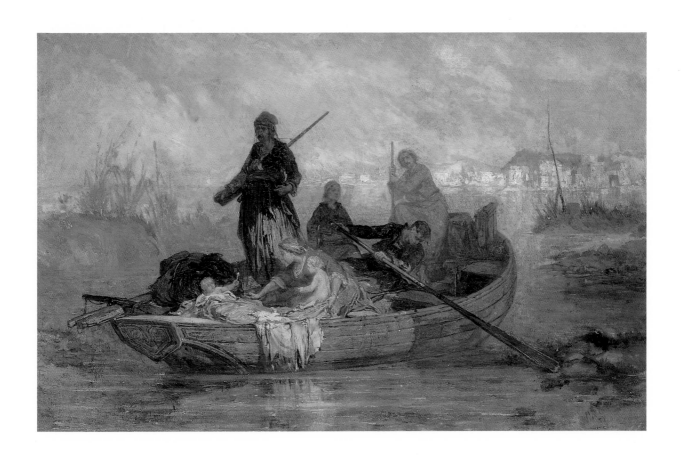

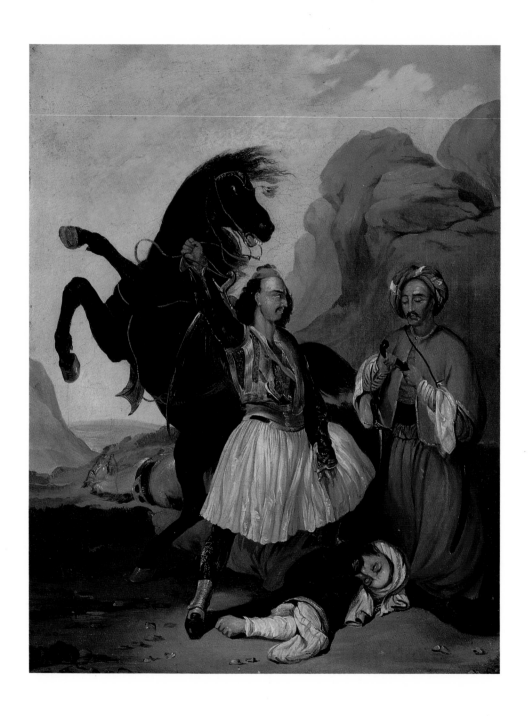

59. THE VICTORIOUS GIAOUR 1827

Antoine-Charles-Horace (Carle) Vernet
(1758-1836)
Oil on canvas
44.0 x 34.0 cm
Inscribed (lower left):
Vernet
Inv. no. 9002

During the second quarter of the nineteenth century the Greek cause found great support among the French liberal opposition, which saw in the Greek War of Independence an analogy of its own struggle against an oppressive regime. As political and artistic liberalism were commonly associated during this period, philhellenic subjects became popular with French Romantic painters. Between 1822 and 1848, more than a hundred paintings of philhellenic subjects were presented in French exhibition rooms. In 1826, an exhibition "au profit des Grecs" was held at the Galerie Lebrun in Paris, in which figured the names of the most eminent Romantic artists of the day, including Delacroix, Ary Scheffer, R. P. Bonington, Achille Devéria, A. M. Colin, and Horace Vernet.

Antoine-Charles-Horace Vernet, known as Carle Vernet and the father of Horace Vernet, was a history painter. A follower of the liberal opposition, Carle Vernet was naturally led to espouse the Greek cause and draw inspiration from philhellenic imagery. According to contemporary descriptions, this picture shows a Greek who treads on the body of a Turk, whom he has just killed. He orders the Turk's servant, depicted on the right, to take his master's head with his own scimitar. One critic of the time attempted to apologize for the grim subject matter by pointing out that "such a cruel act may be justified if one considers the terrific torments that the Greeks suffered under the destructive ottoman presence in Greece."

In his choice of subject, Vernet created a remarkable scene of dramatic confrontation. The Greek holds his impatient horse's bridle with a firm grasp, while the Turk who is about to commit the dread act clasps his scimitar, an intense expression on his face. Viewers are held in suspense at this poignant moment. The Greek's self-confident expression and noble posture betray the artist's wish to justify the action, since the victor also appears to be the defender of freedom.

The picture provides a good example of the Romantic's taste for sensationalism. Vernet's selected topic may have been inspired by Byronic literature on the "Conflict between the *Giaour* and the *Pasha*," a subject widely treated by Romantic artists, especially Delacroix. This theme's explicit statement also embodied a series of Romantic suggestions. The clash between Greek and Turk was seen to personify the struggle between liberty and oppression, between Christianity and the infidel. Certainly in his evocation of the various allusions possible in such a scene, Vernet was aware of the philhellenic sympathies of his audience. In fact, the subject became so popular that from 1827 until the end of the nineteenth century, it was not only repeatedly lithographed, but it was also reproduced in the applied arts, such as in wallpapers and tapestries.

Reference
Benezit, 10:464-65; Thieme-Becker, 34:282; Tsigakou, *Rediscovery*, 49, 51, 71, 195; Athanassoglou-Kallmyer, *French Images from Greek War*, chaps. 3, 4.

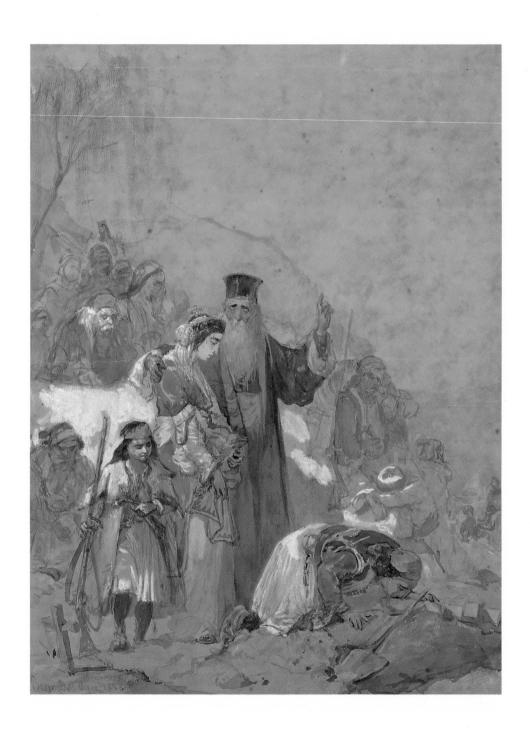

60. SCENE FROM THE EVACUATION OF PARGA 1858

Cesare-Felix-Georges dell'Acqua (1821-1904)
Watercolor on paper
51.0 x 38.0 cm
Inscribed:
Cesare dell'Acqua 1858
Inv. no. 23002

The religious resonances of the Greek War of Independence were as powerful as the liberal ones. The Greeks fought for freedom and faith. Profanations of churches, murders of church dignitaries, and persecution of the Orthodox Greek population made sensational headlines in European newspapers. While Christian public opinion lamented these modern martyrs, the struggle between Cross and Crescent gave rise to a substantial body of imagery. Scenes of warriors receiving the blessing of the church, venerable priests being humiliated, destruction of holy reliquaries, and ferocious Turks eager to rape Christian virgins fired the soul of Greece's Christian brotherhood.

This picture deals with similar subject matter. Before a grave a priest comforts a woman with her son. A man kneels to kiss the ground, while on the right a woman collapses in sorrow. A number of men and women surround this central group. A closer look at the work reveals that the pictorial vocabulary used here relates this scene to a pathetic historical event and a great philhellenic subject—the drama of the town of Parga. When Parga was sold by the British to Ali Pasha (see cat. no. 47), the inhabitants chose to abandon their native land rather than endure Turkish rule. Before their massive sortie they disinterred and cremated their dead lest the remains fall into the hands of the infidels. Upon examination the viewer realizes that the central group of figures in fact form a procession of people carrying their belongings. On the top of the hill to the left, a priest holds a holy cross. To the right the rest of the crowd streams downhill toward the shore, from where they are to embark for their land of exile, the Ionian Islands. The drama of the Parganiotes, much like the fate of the inhabitants of Missolonghi a few years later, deeply affected the Christian community, who saw in it Christianity being tormented by Islam.

In this watercolor the imposing figure of the priest, an emblem of faith and hope, dominates the composition. The Parganiotes were widely deemed the martyrs of religious belief and liberty. To Italian patriots they were seen as the victims of the ruthless intrigues of the Great Powers, and their fate was perceived to parallel Italy's situation as an area where Austrian and French expansionism competed. The most famous and monumental representation of this subject is the large canvas by the Italian painter Francesco Hayez in the National Gallery of Brescia. The Italian history painter Cesare dell'Acqua produced a few philhellenic subjects in the 1850s and 1860s. This particular Greek scene is greatly enhanced by a series of associations and emblems that echo nineteenth-century philhellenic perceptions.

Reference
Benezit, 1:51-52; Thieme-Becker, 1:25; Tsigakou, *Rediscovery*, 55, 196; Spetsieri-Beschi and Lucarelli, *Risorgimento*, 310; Athanassoglou-Kallmyer, *French Images from Greek War*, 83-85, 130-34.

61. GREEKS AFTER A DEFEAT 1826

Henri Decaisne
(or De Caisne)
(1799-1852)
Oil on canvas
58.5 x 72.5 cm
Inscribed (lower left):
Decaisne 1826
Inv. no. 8987

Romantic artists seem to have been inspired more by the tragedies of the Greek War of Independence than by its achievements. They usually depicted the failures of the Greeks, such as the massacre of Chios and the destruction of Missolonghi, rather than their victories. Henri Decaisne (or De Caisne), a Belgian painter who also worked in Paris and was an eminent member of the Romantic school, participated in the Galerie Lebrun exhibition (see cat. no. 59), to which he sent five pictures of philhellenic subjects, including this one entitled *Greeks after the Failure of a Military Operation*. Here, a group of four Greek soldiers on a hilltop gaze at a burning city in the distance. A long line of refugees, mainly women and children carrying their belongings, appear in the left background. The soldiers are portrayed in a highly emotional state: two of them lean against one another for comfort, while the other two sit apart with sorrowful and confused expressions. Descaine created a convincingly gloomy atmosphere in both the figures and the dramatic landscape, with its air filled with smoke. Nevertheless, he lavishly rendered the costumes of the stalwart soldiers, in particular their embroidered jackets and foustanellas, and their elaborately carved pistols.

It has been suggested that this picture may be related to the theme of the evacuation of Parga (see cat. no. 60), with its trail of refugees and the deserted environment. Such a specific narrative element is not important here since this scene could have been inspired by any contemporary report on Greek sufferings. Instead, the artist attempted to create an image with universal significance about the misfortunes of war as he emphasized the stoicism and commitment of the Greeks to their just cause. Decaisne's scene became quite popular, judging from the number of lithographs of it that were issued between 1828 and the late 1830s. It was also copied on porcelain by the Fouqué et Arnoux china factory in Toulouse.

Reference
Benezit, 2:450; Thieme-Becker, 8:512-13; Tsigakou, *Rediscovery*, 49, 55; Athanassoglou-Kallmyer, *French Images from Greek War*, 85; A. Amandry, *L'Indépendence Grecque dans la faience française du 19e siècle* (Nafplion, 1982), 53, pl. 132.

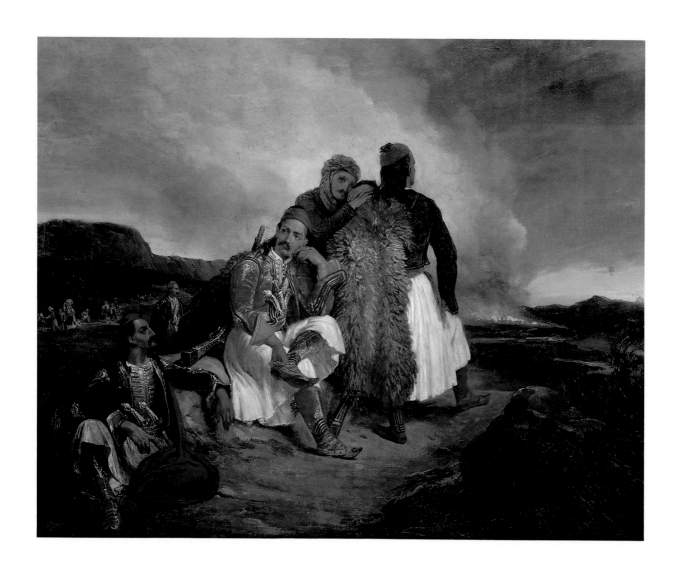

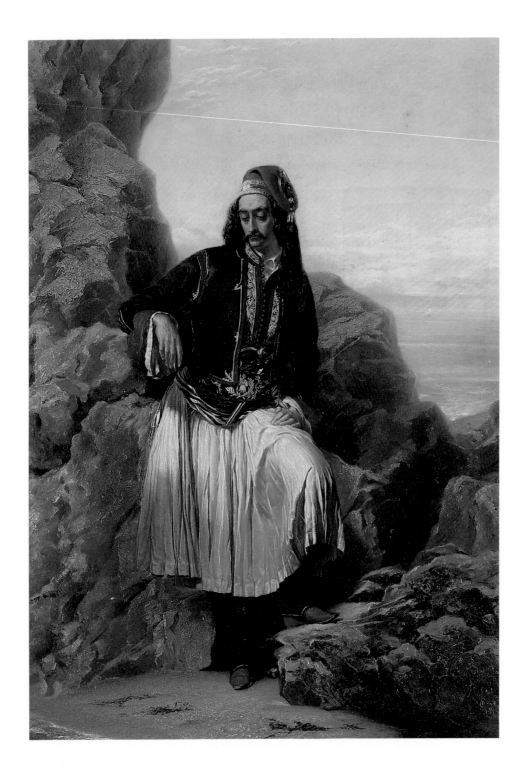

62. A GREEK
Ca. 1830

Louis Dupré
(1789-1837)
Oil on canvas
51.5 x 36.5 cm
Inv. no. 9000

At the beginning of the nineteenth century, European notions of the inhabitants of Greece were wholly nourished by classical literature. The figures shown in the foreground of contemporary European views of Greece were usually represented as decorative elements in an aesthetic schema. Dressed in their brightly colored costumes, they either sit like classical gods among ancient architectural remains or guard their flocks like Virgilian shepherds. Most Western visitors to Greece in the early 1800s had little sympathy for the descendants of the Hellenes, for they hardly matched the foreigners' expectations of what the disciples of Pericles should be like. Yet increasingly it occurred to a growing number of European travelers to question the validity of their assumptions that these people should conform to classical notions of virtue. After all, how could Europeans remain indifferent to the fate of the Greeks when Western civilization was supposed to be based on the values of the ancient Hellenes? While this feeling was heightened by Byron's poetry (see cat. no. 57), it was further intensified by the Greek War of Independence. Reviewing the paintings in the Salon of 1824, a French art critic commented, "I have had enough of the ancient Greeks…. Hector, Achilles, Agamemnon tire me with their sublime nature. What are to me the soldiers of King Priam?… I am more interested in the modern Greeks. It is the Klefts and Armatolis that absorb me entirely." Indeed, after the first quarter of the nineteenth century, modern Greeks substituted their ancient forefathers and took their place in European visual imagery.

When visiting Greece in 1819, Dupré grew distressed by the condition of its inhabitants (see cat. no. 9). In the introduction to his publication *Voyage à Athènes et Constantinople* (1825), he speculated on the future of the enslaved Greeks. "Their history is like a long chain where every link represents a moment of victory and heroism," he wrote, concluding that "this chain has not been broken." This painting serves as an excellent illustration of Dupré's refined taste. The portrait is simultaneously realistic in its meticulous rendering of costume and idealized in its extremely handsome face and graceful posture. It is a noble, "classical" composition. The sitter is supposedly Andreas Londos (1784-1846), a senior official of the city of Aegion, who was one of Byron's first Greek friends and one of the leaders of the Greek War of Independence.

Reference
Benezit, 4:44; Thieme-Becker, 10:177-78; Navari, *Blackmer Collection*, 113; Tsigakou, *Rediscovery*, 99, 188, 191, 195; Tsigakou, *Lord Byron in Greece*, 69-70.

63. A GREEK WARRIOR
Ca. 1830

*Adam Friedel von
Friedelsburg
(act. second quarter of
19th century)
Oil on canvas
35.5 x 29.0 cm
Inv. no. 9027*

In the 1820s and 1830s, the European public·became well acquainted with the leaders of the Greek War of Independence through the large number of lithographs that were then circulating. In 1823, the Swiss history painter Ludvig Vogel was asked by the Swiss Philhellenic Committee to execute the first series of portraits of Greek refugees in Zurich. Italian artist Giovanni Boggi published (1826-29) another collection of portraits of famous characters of the revolution, while the German painter Karl Krazeisen offered to the public (1828-31) the highest quality portraits of these Greek heroes.

From 1825 to 1827, Adam Friedel von Friedelsburg produced a series of lithographed portraits with the title *The Greeks: Twenty-four portraits (in four parts of six portraits each) of the principal leaders and personages who have made themselves most conspicuous in the Greek Revolution, with or without biographical descriptions*. Little is known about Friedel, a Danish philhellene who participated in the Greek War of Independence and after 1827 settled in London, where he published his lithographs. Although drawn from life, Friedel's portraits bear little resemblance to reality. This painting reflects the depth of Friedel's artistic potential. The figure and the details of the costume were executed with great realism but with rather quaint proportions. He stands before a coastal landscape, possibly located in the western region of Epirus, since the structure depicted on the left may be the fortress of Leucas. Shown in full gear, the man leans purposefully against a broken ancient column. Yet despite this allusion to the glorious past, there is nothing heroic about him. Friedel seems to have had in mind the larger public who held a rather picturesque image of the Greeks. He therefore effectively rendered in clean, bright tones a "happy Greek warrior" in a festive dress posed before a pleasant landscape.

Reference
Tsigakou, *Rediscovery*, 56, 57, 196-97.

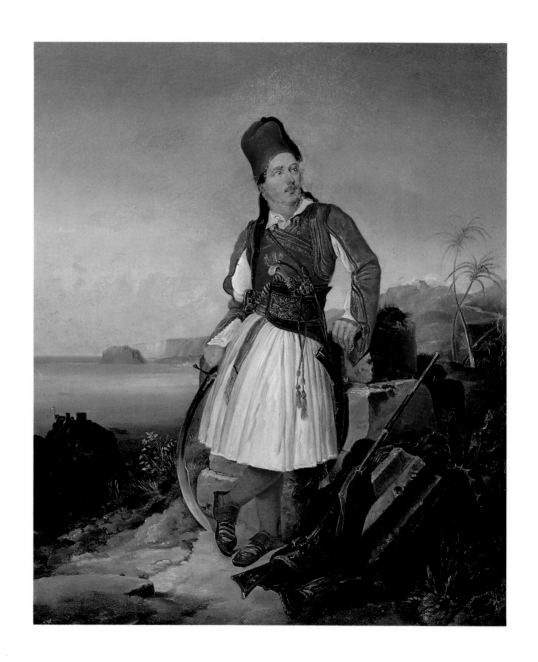

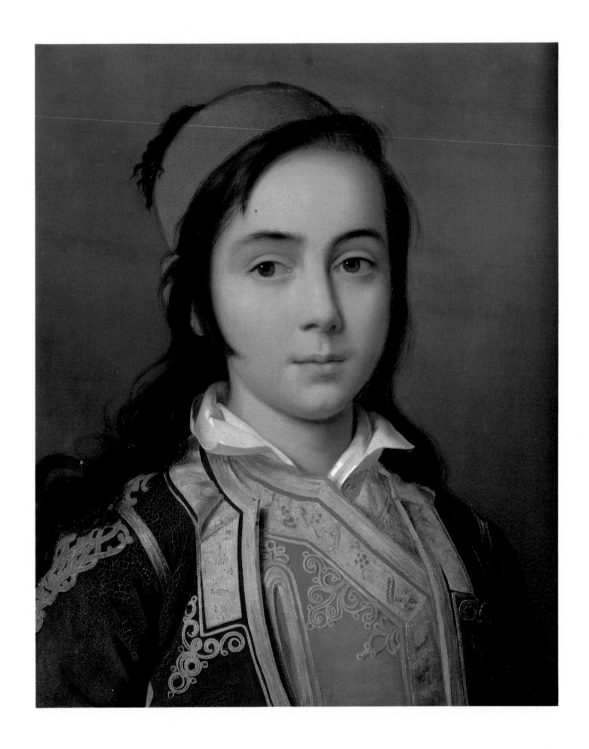

64. PORTRAIT OF DEMETRIOS M. BOTSARIS 1829

Albert Riegel
(act. 1830s-1840s)
Oil on canvas
45.0 x 37.0 cm
Inscribed (verso, in German): Demetrios Bozzaris son of Marco Bozzaris— Born in Suli in Epirus on 4/16 July 1815. A. Riegel pinx. 1829 Inv. no. 8983

Europeans were not only excited by the heroic achievements of the Greek warriors of the revolution, but they were also eager to express their sympathy towards their families. Philanthropic societies all over Europe collected funds for the victims of the war. High society ladies eagerly attended philhellenic balls and bazaars, and performed in charity concerts to raise money to ransom the women and children held prisoner in Greece. From 1825 to 1828, thanks to the generosity of the Duc d'Orleans, future King Louis-Philippe of France, the sons of a number of Greek war heroes were educated in Paris. King Ludwig I of Bavaria, a great philhellene and father of King Otho of Greece, founded a special school in Munich called the Panhellenic Gymnasium, where the orphaned sons of some of the most famous Greek commanders were instructed at the king's expense. Unfortunately, a few of these children could not tolerate the German climate, as indicated by the grave of Leonidas, son of the renowned Greek leader Odysseus Androutsos, in a Munich cemetery.

The sitter in this portrait, Demetrios Botsaris, son of the heroic Suliote leader Marcos Botsaris (see cat. no. 56), was one of the boys who benefited from Ludwig's generosity and was brought to Munich. Born in Suli in 1815, Demetrios was fourteen years old when he sat for Albert Riegel. This portrait appeals equally for its painterly qualities and for the charm of the sitter. The young Botsaris wears his Greek costume and looks proudly into the eyes of the viewer. His elaborately patterned jacket, worn over an embroidered waistcoat and a white shirt, were meticulously painted in bright tones. Set against a bare background, the boy possesses none of the attributes of his youth, nor are the domestic surroundings that usually accompany children's portraits included. A sense of innocence, purity, and piety emerges from this simultaneously realistic and heroic portrait of a handsome child, whose personal history was intertwined with his country's struggle. The German portraitist Riegel must have painted this work under a commission from Ludwig I. According to the Benaki Museum archives, the provenance of this painting is King Ludwig's personal art collection.

Reference
Thieme-Becker, 28:325.

65. A YOUNG GREEK DEFENDING HIS WOUNDED FATHER 1827

Ary Scheffer
(1795-1858)
Oil on canvas
45.0 x 37.0 cm
Inv. no. 11177

The subject of the Greek boy was quite popular with European artists inspired by the War of Independence. Farewell scenes of a Greek youth leaving his family and heading for the battlefield, defending his mother and sisters, or fighting next to his father were often represented in philhellenic works. The presence of children in such historical images revealed the artists' intention that these events be instructive and morally improving. Such is the case with this work by Ary Scheffer, a portraitist and history painter of Dutch origin who worked in France and rose to become one of the most popular artists of the French Romantic school.

Scheffer, who for some time shared a studio with Delacroix, became interested in the philhellenic movement and participated in the exhibition "au profit des Grecs" at the Galerie Lebrun in 1826 (see cat. no. 59). Between 1825 and 1830, he painted approximately ten pictures based on contemporary events in Greece. (The title of this image is known from a French lithograph issued in 1829.) This is another history painting in which the decisive moment is allied to a personal drama, as when a young boy is forced to defend his wounded father on the battlefield. It is an intense scene dedicated to posterity and love of country. The boy tenderly holds his wounded father's arm, while with the other hand he points a pistol at the enemy. Invested with classical ethos and bravery, the youth realizes his duty in the midst of unfortunate circumstances, leaving no doubt that he will be able to take his father's place.

The painting casts its spell in emotional terms when the viewer empathizes with the boy's agony in a situation that must be unnatural for his tender years. Beside filial devotion, Scheffer emphasized such ideals as patriotism and moral virtue, which were believed to be characteristics of the Greeks throughout the ages. Indeed, the boy's classical profile and his father's dignified posture subtly allude to the youth's heritage. The message of the painting is obvious: for a Greek, to fight for his father and for freedom is one and the same thing. Such a scene not only moved the heart but also sanctified the Greek cause. A talented Romantic artist, Scheffer created an economical composition rich in pictorial values and allusion.

Reference
Benezit, 9:353-54; Thieme-Becker, 30:3-5; M. Kolb, *Ary Scheffer et son temps* (Paris, 1937), 306; *Ary Scheffer 1795-1858* (Paris, 1980), 14-15, 82-90; Tsigakou, *Rediscovery*, 49, 54, 55, 66, 196.

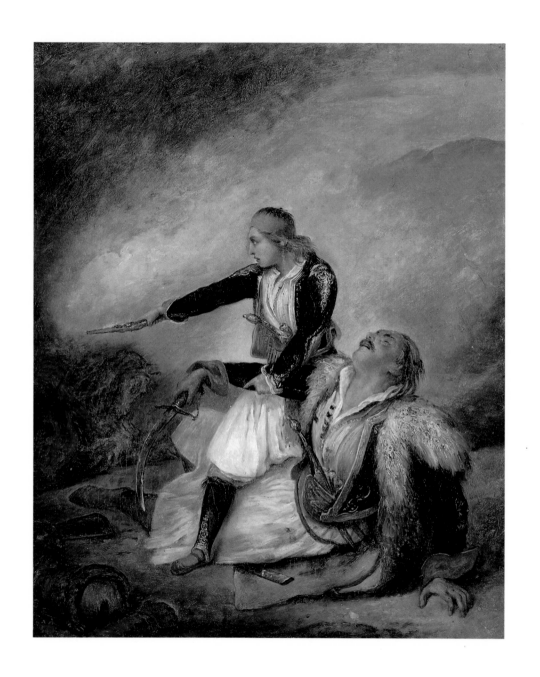

66. A GREEK BOY
Ca. 1829-30

Alexandre-Marie Colin
(1798-1873)
Oil on canvas
44.0 x 38.0 cm
Inscribed (lower left):
A. Colin
Inv. no. 21794

Even when the Greek War of Independence was over, portraits of Greeks continued to attract painters, although artists often used such works as an excuse to indulge in the current taste for images of foreign costumes and miscellaneous exotica. This portrait may be viewed within this tradition. The French painter Alexandre-Marie Colin, who never visited Greece, was among those Romantic painters, including Delacroix and Bonington, who were working Paris in the 1820s. Bonington is known to have made drawings of models wearing Greek costumes, and Colin may well have executed this figure in the same manner. Depicted in traditional Greek dress (see cat. no. 21), the boy's costume consists of a pleated skirt of white cotton (*foustanella*), a wide-sleeved shirt, a tight waistcoat (*yileki*), an elaborately patterned jacket (*fermeli*) with the sleeves thrown over the shoulders, and a folded cloth belt in which warriors carried their pistols and knives. Richly embroidered gaiters, called *touzloukia*, that reach to the knee appear over long, white stockings and shoes with upturned ends (*tsarouhia*). A red skullcap with gold tassels completes the ornate costume.

Instead of the attributes of childhood, this boy is surrounded by powder and cartridge cases. Piled on the right are muskets and swords that are much too big for him and make him look like a toy soldier. In his pictorial conception of this youth, Colin may have been inspired by contemporary French philhellenic literature, especially that of Victor Hugo. In 1829, this apostle of French Romanticism published *Les Orientales*, a collection of poems with philhellenic overtones. In the poem "L'enfant Grec," Hugo describes how a young Greek boy was offered one of the world's marvels. Instead, he demanded "powder and cartridges," thus fueling the reader's appreciation of the rightful justification of the Greek struggle. Beyond possibly alluding to this well-received poem, Colin's interpretation of the boy as a man, the meticulous delineation of his costume, and the presence and careful rendering of the weapons may reveal the artist's attempt to invest the scene with a greater didactic context. In that sense, the Greek boy, painted soon after the Liberation, may have been seen as the youthful incarnation of the new Greece's national identity.

Reference
Benezit, 3:105; Thieme-Becker, 7:202-204; Tsigakou, *Rediscovery*, 49, 66, 198.

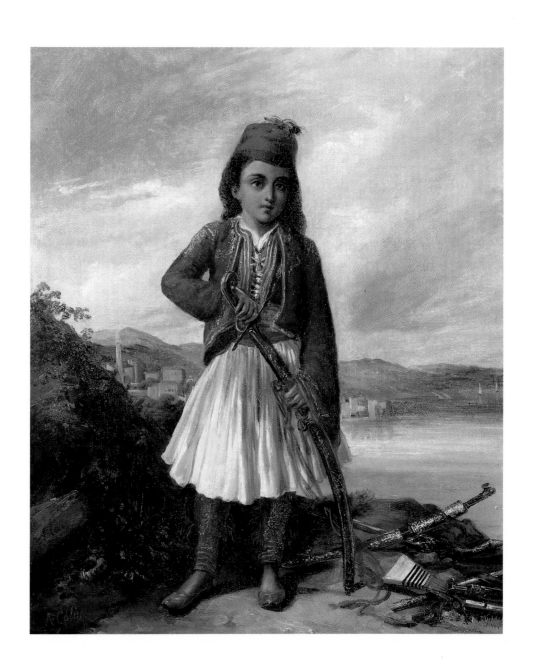

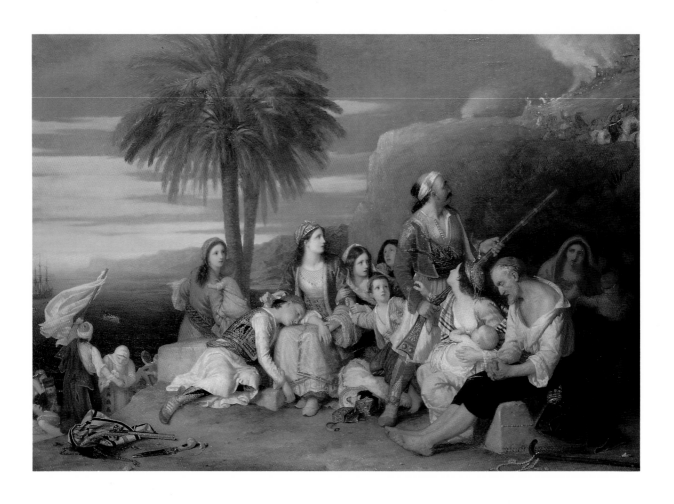

67. GREEK FUGITIVES 1833

Sir Charles Lock Eastlake (1793-1865)
Oil on canvas
95.0 x 134.0 cm
Inscribed (lower right):
C. L. Eastlake
Inv. no. 8996

In the 1820s in England, religious, humanitarian, scholarly, and political reasons for and against lending assistance to the Greeks combined to make intervention in the Greek War of Independence a burning issue of the day. The London Philhellenic Greek Committee was founded in 1822. Even though England played a major role in the philhellenic movement and in Greek affairs throughout the war, few British artists alluded to it—the most notable exceptions being J. M. W. Turner, Thomas Barker of Bath, and Charles Lock Eastlake. A history painter and an influential artistic personality of Victorian England, Eastlake became president of the Royal Academy and received a knighthood from Queen Victoria. He visited Greece in the spring of 1819 and produced ten oil paintings of Greek subjects, which were exhibited at the Royal Academy between 1820 and 1837.

Presented in 1833 with the title *Greek Fugitives: An English ship sending its boats to rescue them*, this painting shows a group of Greeks, mainly women and children, fleeing from their town, which is seen in flames on the top of the hill to the right. A man with a wounded head stands watching the enemy approach down the hill on horseback. An old man sits exhausted in the foreground, stoically awaiting his fate. On the left another wounded man waves a white flag to a ship on the horizon. In terms of subject matter, the scene may have been inspired by tragic events on the island of Chios, an assumption based on the fact that this painting was shown at the London International Exhibition of 1862 with the title *Refugees from Chios*. In April 1822, Turkish troops raided the island, slaughtered most of its inhabitants, and dragged off women and children to the slave markets of Asia Minor. Eastlake, however, completed this painting in 1833, the year of the proclamation of the new Greek kingdom. Rather than illustrate the horrors of Chios, the artist may have intended to praise the British role in Greek affairs. Indeed, the ship seen on the horizon flies the British flag. According to a contemporary description, "The picture represents an episode of that devastating war in which…the unfortunate Greeks sometimes found safety on board the British ships stationed on the coast, and which were on the watch to succour them."

Whatever its impetus, this theme must have won the hearts of its British admirers. In composition it is an excellent example of a history painting catering to the tastes of the Victorian public, for it embodies a wealth of popular conceptions about patriotism, motherhood, and the innocence and vulnerability of childhood. Moreover, the religious principles of this desperate group of refugees are represented by the icons and holy relics they try to safeguard. Significantly, the old man in the foreground rests on a piece of ancient marble. Together, these elements offer the moral message that virtue, faith, and heroism are rewarded.

Eastlake achieved a masterful combination of historical fact and purely pictorial values. Sky and landscape are exquisitely rendered; costumes and weapons are painted with a remarkable degree of accuracy. Although the artist portrayed the terror these women and children feel as they sense their impending end, being a true Victorian, he did not wish to upset his audience. The refugees are shown with tears on their faces, but not a hair is out of place and their handsome clothes are in impeccable condition.

Reference
Benezit, 4:93; Thieme-Becker, 10:2868; D. Robertson, *Sir Charles Lock Eastlake and the Victorian Art World* (Princeton, N.J., 1978); Tsigakou, *Rediscovery*, 66, 67, 137, 194, 198, pls. IV, XIX.

68. SOLDIERS OF THE FRENCH EXPEDITION IN THE PELOPONNESE 1828

Noel Dieudonné Finert
(1797-1852)
Oil on canvas
56.0 x 71.5 cm
Inv. no. 11175

Although at the beginning of the revolution the Greeks had hoped that Europe would bless their enterprise, throughout the years of their struggle mutual distrust between the Great Powers—here, Great Britain and Russia—frustrated a number of tentative interventionist proposals. The landing of Egyptian troops under Ibrahim Pasha in the Peloponnese in 1824 forced a change of policy upon them. The Great Powers recognized that if there was to be any stability in the eastern Mediterranean, collective action was needed. In April 1826, an Anglo-Russian protocol was signed, by which the two nations agreed on British mediation between the Turks and the Greeks, with the object of making Greece an autonomous vassal state of the Ottoman Empire. At the end of that year the two powers asked Austria, Prussia, and France to share in the peacemaking process in Greece, but only France accepted the invitation. On July 6, 1827, the three governments concluded the Treaty of London, and their naval commanders in the Mediterranean were ordered to cut off supplies from Egypt. The naval battle of Navarino in the Peloponnese was fought on October 10 and ended in the total defeat of the Ottoman fleet.

A year after the Battle of Navarino, the Great Powers decided to force the Egyptian troops under Ibrahim Pasha to evacuate the Peloponnesus. The French army undertook the task, and on August 30, 1828, an army of 14,000 men under the command of General Maison landed at Petalidi. With the Peloponnesus expedition, France sought to secure a dynamic presence in the East and to demonstrate to Europeans and Greeks alike its decisive contribution to the liberation of Greece. Within a month of the French army's arrival, the Egyptian forces had left the area. Beyond military goals, the French presence in the Peloponnesus served a scientific purpose. The French government also sent a group of scientists, who for two years surveyed the topography, flora, archeology, and architecture of the area. The results of their extensive research were published in a monumental, three-volume work entitled *Expedition Scientifique de Morée* (1831-33).

While in military terms the expedition in the Morea offered France the opportunity to project the image of a benevolent, magnanimous nation, it also furnished French artists with a fresh repertoire of themes that praised the French role as protectors of the oppressed and apostles of liberty. Here, soldiers of the allied nations of France and Greece gather on the seashore where the French troops are anchored (i.e., the Gulf of Petalidi, near Coron, in the southern Peloponnese). In the foreground French soldiers engage in a friendly discussion with two Greeks. On the left, a French soldier instructs a Greek in the use of the cannon next to them. Despite the military nature of the figures, the scene appears peaceful. Noel Dieudonné Finert, a self-taught and talented French painter who specialized in genre and military scenes, obviously tried to convey the cooperative spirit of the Franco-Greek collaboration. The presence of women and children on the left adds a touch of spontaneity and an element of everyday life to the scene. Even though the importance of this painting lies in its unpretentious anecdotal character, Finert also took the opportunity to project an impeccable public image of his compatriots.

Reference
Benezit, 4:370; Papadopoulos, *Liberated Greece*; Tsigakou, *Rediscovery*, 61-62; Athanassoglou-Kallmyer, *French Images from Greek War*, 118-29.

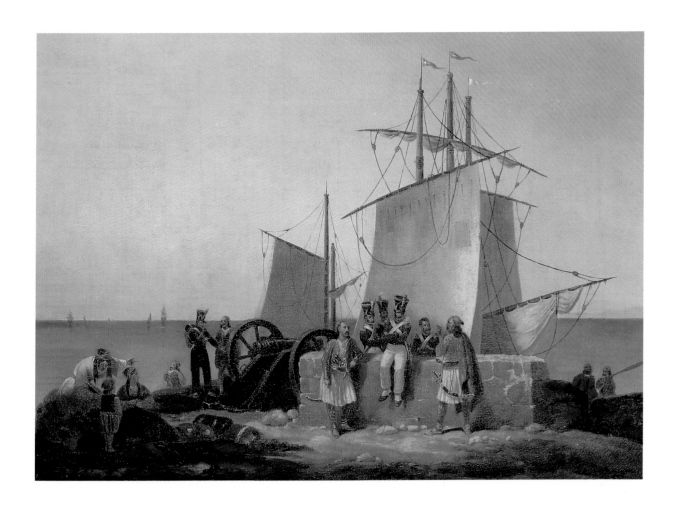

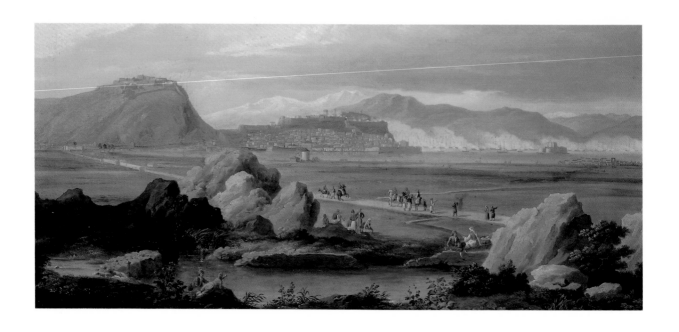

69. THE ALLIED FLEETS SALUTE GREEK INDEPENDENCE AT NAFPLION
Ca. 1829-30

Unknown
Oil on canvas
46.0 x 99.0 cm
Inv. no. 9023

The city of Nafplion charmed nineteenth-century visitors with its picturesque location on the shores of the Gulf of Argolis. It lies at the foot of a rocky crag, called Palamede, and overlooks the fortified islet of Bourtzi (see cat. no. 53). An important port of the Peloponnese, Nafplion bears the traces of many centuries of Venetian domination on its attractive architecture and the fortress of Palamidi, which towers impressively over the city. Its geographical position and its cosmopolitan appearance caused this city to be declared the first capital of liberated Greece (1829-34) and the seat of Governor Capodistrias. It was in Nafplion that King Otho was welcomed by his new subjects on first landing in Greece on February 6, 1833. A few months later the classically minded young monarch appropriately transferred the capital of the Hellenic kingdom to the most glorious city of Greece—Athens.

Prior to these events, and following the victory of Navarino in 1827 (see cat. no. 68), the Greek National Assembly at Troezene drafted a new constitution and elected Count Ioannis Capodistrias (1776-1831) the first governor of Greece for a period of seven years. Capodistrias, the greatest statesman of nineteenth-century Greece, made superhuman efforts to transform the post-revolutionary country into a modern state. Unfortunately his efforts were cut short by his assassination in 1831 in Nafplion.

This painting commemorates Capodistrias' arrival in Nafplion on January 7, 1828. The composition presents an extensive view of the countryside around Nafplion and the Gulf of Argolis. Following the line of the old city wall the eye is led to the city itself, which is densely built up and occupies the rocky promontory of Acronafplia. The sheer mass of Palamede crowned by the Venetian castle fills the left background. Capodistrias entered the port of Nafplion aboard the British flagship *Warspite* escorted by the allied warships seen in the middle distance. Their presence is almost obscured by the clouds of smoke caused by their cannon salutes. Their masts decorated with multicolored flags underscore the festive occasion of the scene.

The road to Nafplion is crowded with brightly clad Greeks riding to the city. In the foreground a somewhat artificial lake is bordered by picturesque rocks and foliage rendered with subtle delicacy. Two carefully posed figures gaze at the view, and one points to the background where the action takes place. This clever device suggests that these two figures are also spectators who invite the viewer to share their experience. The whole foreground is precisely staged to create a setting that introduces the "performance" in the middle distance. Although the artist is unknown, it must have been someone who was well aware of the great landscape tradition in order to create such an extensive and meticulously observed scene enveloped in a luminous atmosphere appropriate to this specific historic event.

Reference
A. Delivorrias, *Guide to the Benaki Museum* (Athens, 1980), 110; Delivorrias, *Greece and the Sea*, 354, pl. 261.

70. PORTRAIT OF KING OTHO 1832

Joseph Stieler
(1781-1858)
Oil on canvas
72.0 x 58.0 cm
Inv. no. 8986

The assassination of Count Ioannis Capodistrias (see cat. no. 69), the first governor of the infant Greek state, in October 1831 was followed by a period of chaos in Greece. Four months later the Great Powers—Britain, France, and Russia—agreed on Prince Otho (1815-1867), the seventeen-year-old son of King Ludwig I of Bavaria, as ruler of Greece. On February 6, 1833, King Otho landed at Nafplion, accompanied by the three Bavarian regents Amansberg, Maurer, and Heideck (see cat. no. 55), who were to govern until the young monarch came of age, and 3,500 Bavarian troops. Otho's Greek kingdom embraced within its boundaries only about half the Greek population. Thessaly, Epirus, and Macedonia were excluded, as were Crete and most of the islands, except those immediately adjacent to the mainland.

Otho's reign was not a happy one. Sporadic rebellion and brigandage continued. On September 3, 1843, a bloodless revolution in Athens compelled the king to yield to popular will and concede to a constitution, which was promulgated in March 1844. With the implementation of a constitution, all foreigners were excluded from public office, and Otho, a Roman Catholic in an Orthodox country, was forced to specify that his eventual successor be Orthodox. (His wife, Amalia of Oldenburg, whom he married in 1836, never gave him an heir.)

The 1840s were marked by nationalistic movements throughout Greece, which led to the continual intervention of the Great Powers in Greek affairs and caused Greece to be derided in Europe. In 1852, British warships blockaded Piraeus. A series of revolts and diplomatic interventions led to Otho's deposition and deportation on October 23, 1862. Constantly asserting his affection for Greece, Otho never relinquished his claim to the throne, although he lived only five years more. History has judged him less harshly than his contemporaries.

This painting by Joseph Stieler, a popular portraitist and a favorite of King Ludwig I, who sat for him a number of times, shows a young prince Otho in an official uniform. In terms of pose and style, the artist was influenced by traditional seventeenth-century portraits by European masters. A quietly posed nobleman, shown half-length and set against a neutral open-air background, directs his glance away from the viewer. A closer look at the background, under the sitter's right arm, reveals the familiar motif of the Acropolis, which suggests that this portrait must have been painted after Otho's nomination as king of Greece. This is one of the few existing portraits of Otho in Western dress, for soon after his arrival in Greece he adopted the traditional Greek male costume, which he never abandoned. He was even buried in it. This elaborately painted work possesses the noble simplicity that characterizes Stieler's portraits, especially those of Ludwig I and of Goethe (Neue Pinakothek, Munich).

Reference
Benezit, 9:832; Thieme-Becker, 32:42; Neue Pinakothek, *Catalogue of Paintings* (Munich, 1981), 327; C. M. Woodhouse, *The Story of Modern Greece* (London, 1968), 157-59.

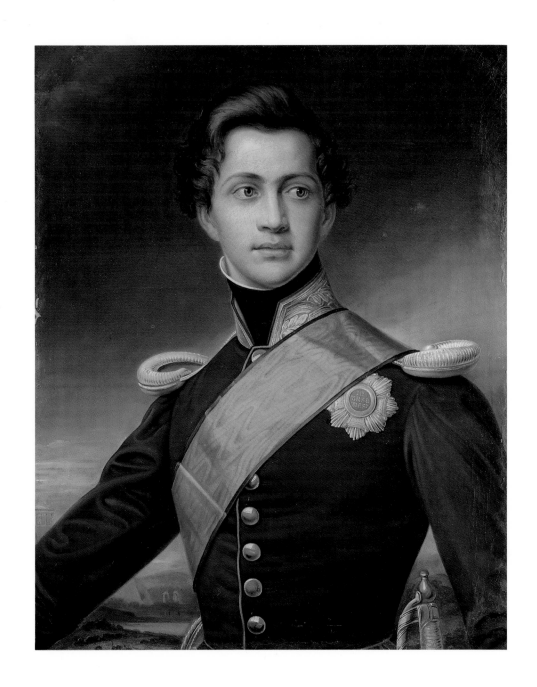

Selected Bibliography

Amandry, A. *L'Indépendence Grecque dans la faience française du 19e siècle.* Nafplion, 1982.

Athanassoglou-Kallmyer, N. *French Images from the Greek War of Independence 1821-1830.* New Haven, Conn., 1989.

Athen-München. Bayerisches Nationalmuseum Bildführer 8. Munich, 1980.

Athens 1839-1900: A Photographic Record. (Exh. cat.) Athens, 1985.

Athens from the end of the ancient era to Greek Independence. (Exh. cat.) Athens, 1985.

Attopardi, C. J. *The Schranz Artists: Landscape and Marine Painters in the Mediterranean.* Medina, Malta, 1987.

Benezit, E. *Dictionnaire critique et documentaire des peintres, sculpteurs, dessinateurs et graveurs.* Paris, 1976.

Boppe, A. *Les peintres du Bosphore au 18e siècle.* Paris, 1911.

Colvin, H. M. *A Biographical Dictionary of English Architects, 1660-1840.* London, 1954.

Dawson Damer, Mrs. G. L. *Diary of a Tour in Greece, Turkey, Egypt and the Holy Land.* London, 1841.

Delivorrias, A., ed. *Greece and the Sea.* (Exh. cat.) Amsterdam, 1987.

—————————. *Guide to the Benaki Museum.* Athens, 1980.

Hardie, M. *Watercolour Painting in Britain.* 3 vols. London, 1968.

Hatzimichali, A. *The Greek Folk Costume.* 2 vols. Athens, 1977.

Helsted, D., et al. *Martinus Rørbye 1803-1848.* Copenhagen, 1981.

Holland, H. "Joseph Scherer." *Die Christliche Kunst* 11 (1914-15): 33-34.

Huisman, P. *French Watercolours of the 18th century.* London, 1969.

Ioannou, A. S. *Greek Painting: 19th Century.* (In Greek.) Athens, 1974.

Kokkou, A. *The Conservation of Antiquities in Greece and the First Museums.* (In Greek.) Athens, 1977.

Kolb, M. *Ary Scheffer et son temps.* Paris, 1937.

Lydakis, S. *Dictionary of Greek Painters.* (In Greek.) Athens, 1976.

Navari, L. *Catalogue of the Blackmer Collection.* London, 1989.

Noakes, V. *Edward Lear 1812-1888.* London, 1985.

Papadopoulos, S. *Liberated Greece and the Morea Scientific Expedition, The Peytier Album.* Athens, 1971.

Papanikolaou-Christensen, A. *Athens 1818-1853: Views of Athens by Danish Artists.* Athens, 1985.

Papantoniou, I. *Greek Costumes.* Nafplion, 1981.

Redgrave, S. *A Dictionary of Artists of the English School.* London, 1970.

Robertson, D. *Sir Charles Lock Eastlake and the Victorian Art World.* Princeton, N.J., 1978.

Sailing Ships from Galaxidi. Galaxidi, 1987.

Ary Scheffer 1795-1858. Paris, 1980.

Smith, A. H. "Lord Elgin and his collection." *Journal of Hellenic Studies* 36 (1916): 173-75.

Spetsieri-Beschi, C., and E. Lucarelli. *Risorgimento Greco e Filellenismo Italiano.* (Exh. cat.) Rome, 1968.

St. Clair, W. *Lord Elgin and the Marbles.* London, 1967.

Thieme, U., and F. Becker. *Allgemeines Lexicon der bildenden Künstler von der Antike bis zur Gegenwart.* 36 vols. Leipzig, 1908-74.